The DK Art School

WATERCOLOR
LANDSCAPE

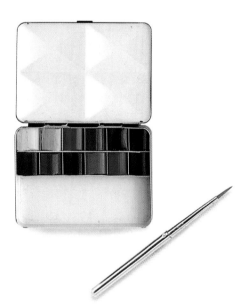

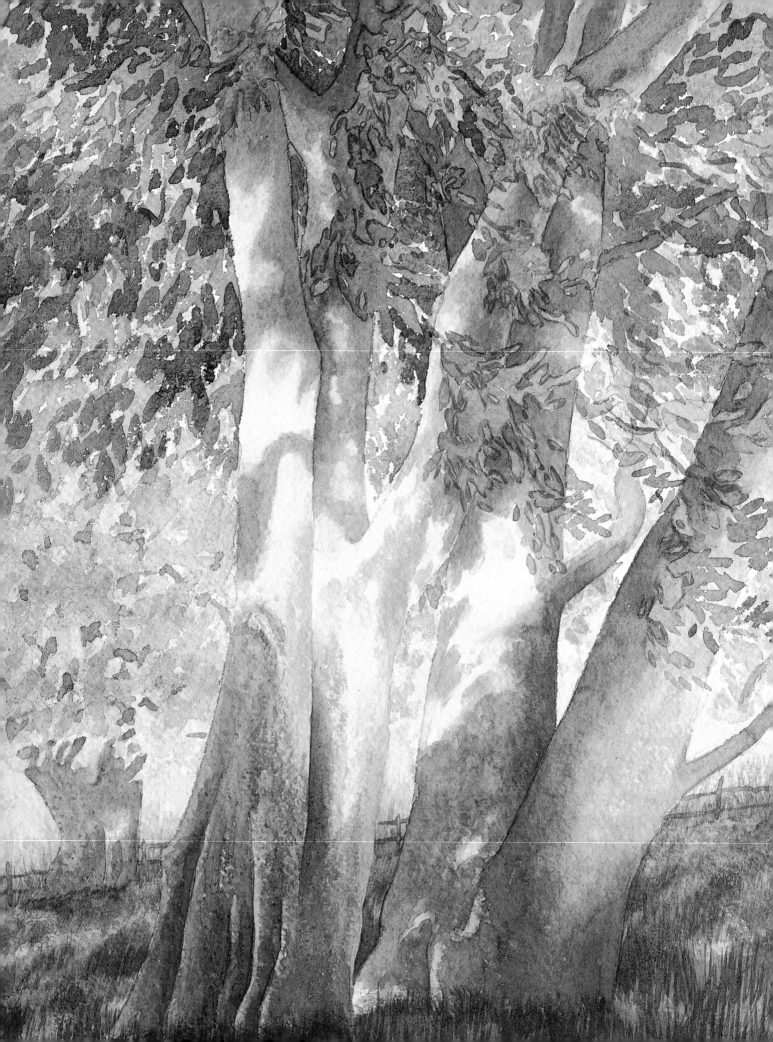

The **DK** Art School

WATERCOLOR
LANDSCAPE

EDITORIAL CONSULTANT RAY SMITH

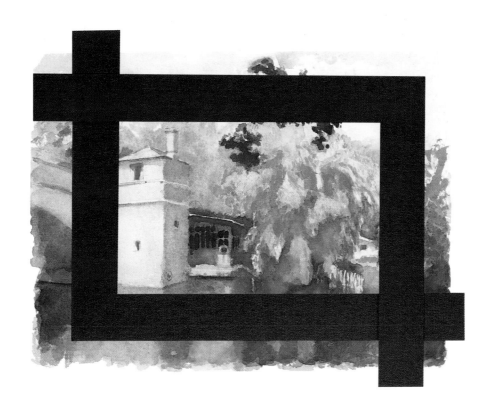

DORLING KINDERSLEY
LONDON • NEW YORK • STUTTGART
IN ASSOCIATION WITH THE ROYAL ACADEMY OF ARTS

A DORLING KINDERSLEY BOOK

Project editor Marcus Hardy
Art editor Brian Rust
Assistant project editor Tessa Paul
Assistant editor Joanna Warwick
Design assistant Dawn Terrey
Senior editor Gwen Edmonds
Senior art editor Toni Kay
Managing editor Sean Moore
Managing art editor Tina Vaughan
US editor Laaren Brown
DTP manager Joanna Figg-Latham
Production controller Helen Creeke
Photography Phil Gatward

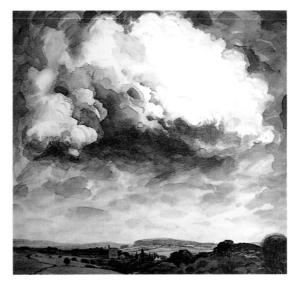

First American Edition, 1993
2 4 6 8 10 9 7 5 3 1

Published in the United States by
Dorling Kindersley, Inc., 232 Madison Avenue
New York, New York 10016

Copyright © 1993
Dorling Kindersley Limited, London

Library of Congress Cataloging-in-Publication Data

Smith, Ray, 1949-
 Watercolor landscape / editorial consultant: Ray Smith. -- 1st American ed.
 p. cm. -- (Dorling Kindersley art school)
 Includes index.
 ISBN 1-56458-275-2
 1. Watercolor painting--Technique. 2. Landscape painting--....Technique. I. Title.
II. Series.
ND2240.S64 1993
751.42'2436--dc20 92-38770
 CIP

Color reproduction by Colourscan in Singapore
Printed and bound in Italy by Graphicom

CONTENTS

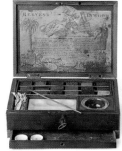

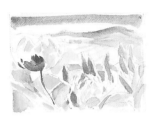

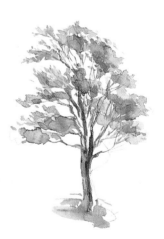

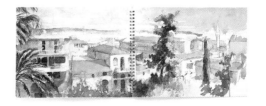

INTRODUCTION

WATERCOLOR PAINTING has many attractions for the painter. The materials required are simple – a few brushes, paint, and water – which means your artistic kit can be carried anywhere. The fresh spontaneous quality of the paint makes you long to rush outdoors to capture the fleeting light and subtle shades of the landscape with free brushstrokes. It is also a medium which encourages you to draw as you paint, so keep a sketchbook handy.

Albrecht Dürer, *House on an Island,* **c.1495**
Dürer exploited the transparency and delicacy of watercolor by building up layers of color and merging wet brushstrokes. His style anticipates Cézanne's approach some four hundred years later, casting Dürer as the father of modern watercolor painting.

The modern watercolor

Despite the artistic demands that watercolor offers the painter, European art has been dominated since the 16th century by oil painting. Watercolor was then ignored or downgraded, its main use being in the preparation of sketches for large works in oil. However, Albrecht Dürer (1471-1528) p.6, a genius of poetic nature studies, used watercolor as a serious medium, as did the French painters Claude Lorrain (1600-82) p.17 and Nicholas Poussin (1593-1665). These two artists developed the use of washes and monochrome (one color). But it was the work of the great English painters Paul Sandby

Raw Sienna
This is a natural earth pigment that occurs in northern Italy. It produces a grainy, bright yellow-brown color, that makes it extremely suitable for painting landscapes.

Terre Verte
This natural pigment was used as artists' color by the Romans. It produces a blue-gray to olive-green color, and is sometimes referred to as green earth. It originates in Cyprus.

Indian Yellow
This is made from puréed earth, urinated on by water-deprived cows fed on mango leaves.

Prussian Blue
Introduced in the 1720s, this was one of the first pigments to be manufactured synthetically. It produces a deep strong blue.

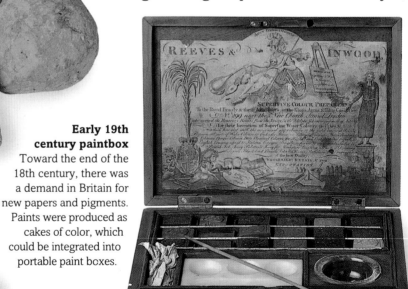

Early 19th century paintbox
Toward the end of the 18th century, there was a demand in Britain for new papers and pigments. Paints were produced as cakes of color, which could be integrated into portable paint boxes.

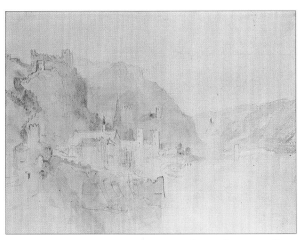

J.M.W. Turner RA,
***On the Rhine,* 1817**
Turner made many tours around Britain and Europe. This is one of a series of delicate watercolors painted in the Romantic style from pencil sketches of the banks of the Rhine.

(1725-1809) p.29, John Constable (1776-1837) p.16, p.40 and J.M.W. Turner (1775-1851) p.7, p.41, that returned to the medium of watercolor the serious consideration that it deserved. The complex color tones and free brushwork of these painters inspired many professionals and amateurs in English society of the nineteenth century, but the medium gained further significance when it was adopted by the French Impressionists. A leading painter of this group, Paul Cézanne (1839-1906) p.35, became a master watercolorist. The German August Macke (1887-1914) p.49 and the American Winslow Homer (1836-1910) p.57 introduced bold, forceful techniques that enhanced the importance of modern watercolor painting.

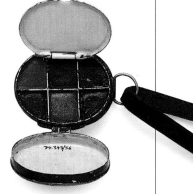

Pocket Box *c*.1900
The popularity of the watercolor medium produced a variety of portable accessories. This pocket box has all the colors needed to sketch a landscape.

About this book
This book takes you through the principles of handling color, light, and tone in the medium of watercolor. Composition is explained and technical tips are given throughout. Once you have practiced the basic techniques, you will soon be capable of painting skillful and professional landscapes. Illustrations of historical and modern works of art have been used to both inform and inspire you in your progress.

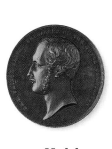

Medals *c*.1850
Watercolor, and manufacturers of watercolor materials, enjoyed immense patronage. These medals, showing the heads of Prince Albert and Napoleon, were commissioned for the world fairs of 1851 and 1855.

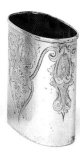

Silver water bottle and brush carrier
These exquisitely made artists' accessories were produced in an age when watercolor painting was a hobby for rich amateurs.

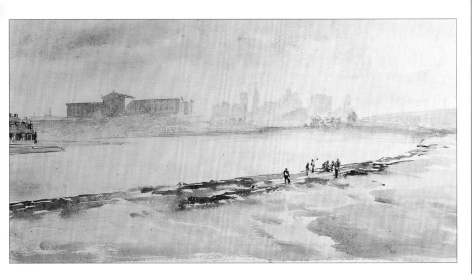

James McBey, *Philadelphia,* 1932
The Scot, James McBey, is one of the many 20th century artists who have chosen to work and exhibit in the United States. This painting is of an American theme; the work party in the foreground reminds us of the human endeavor implicit in the city.

WATERCOLOR MATERIALS

To START PAINTING WITH watercolor, you will need a pencil, a medium and a fine brush, a range of colors, and paper. You will also need water to dilute your paints and a palette to mix them on. You can build up your materials to include two sizes of wash brush, a medium-size brush, and one or two fine brushes. Watercolor paints come either in pans *(left)* or in tubes. There is no great difference, but tubes are better when using large quantities. There is a vast array of papers to choose from, so experiment until you find one to suit your subject or technique.

Turner Gray

Bockingford 140lb NOT

Winsor and Newton 90lb NOT

Saunders Waterford 140lb NOT

Arches 90lb

Paint box
A portable box of watercolor paints contains a basic range of pigments, from which you can mix an infinite color range.

Small watercolor brush for sketching

Paper
There is huge variety of paper, machine and handmade. The three basic surfaces of machine-made are HP or Hot-Pressed, with a smooth texture, CP, Cold-Pressed or NOT, with a semi-smooth surface, and Rough, which is as it sounds.

Easel
This metal easel *(above)* is light and can be folded down to a compact, manageable size. Increasingly, modern easels like this are used in place of bulkier and heavier wooden easels *(right)*. However, some wooden easels have drawers in which to store materials.

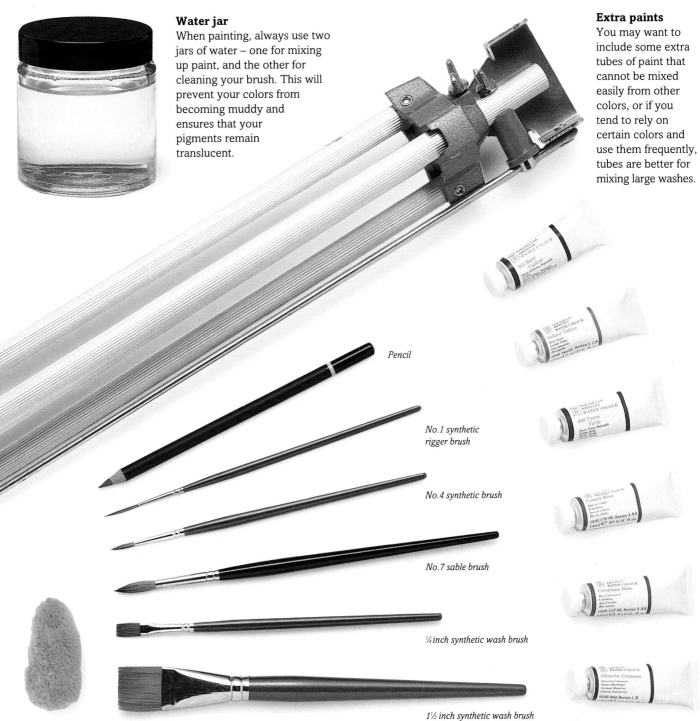

Water jar
When painting, always use two jars of water – one for mixing up paint, and the other for cleaning your brush. This will prevent your colors from becoming muddy and ensures that your pigments remain translucent.

Extra paints
You may want to include some extra tubes of paint that cannot be mixed easily from other colors, or if you tend to rely on certain colors and use them frequently, tubes are better for mixing large washes.

Pencil

No.1 synthetic rigger brush

No.4 synthetic brush

No.7 sable brush

¼ inch synthetic wash brush

1½ inch synthetic wash brush

Sponge
Soak up excess paint from the surface of the paper with a sponge, but use it gently.

Gouache
Gouache, or body color, is opaque watercolor. Unlike other watercolors it has a matte appearance. White gouache is useful for highlights.

Palette
A palette to mix colors on is essential for any painting medium. This watercolor palette has shallow troughs designed to hold pigment diluted in water. If you buy a set of watercolor pans, the lid of the box usually doubles as a small palette. Most washable containers can serve as a palette, including saucers, plates, cups, and jars.

9

GETTING STARTED

CHOOSING A LANDSCAPE to paint may be somewhat daunting at first. Try not to worry about the right "artistic" view; it is fine to work from a photograph or a postcard if you have one that you like. Starting in this way will allow you to develop the confidence to take your materials outdoors later. Remember, you are practicing, so accept any mistakes as part of your learning process. Watercolor is a superb medium for conveying impressions, so do not be overly concerned about reproducing the details in your photograph. In these examples the artist has used sweeps of paint to capture the effects of light found in his photograph. Try not to use more than three colors in your painting; work from a limited palette. Initially, apply the paint with a liberal quantity of water on your brush to keep the color pale. At this stage it is easier to darken the tone once the first layer of paint has dried than it is to lighten it after it has been laid on the paper.

Colors at sunset
Only three colors have been used in this painting. The first application was Cadmium Yellow, followed by Alizarin Crimson, then French Ultramarine (referred to throughout as Ultramarine). Part of the first wash was left uncovered to create the light of the sun and its reflection.

Wash over pencil
Working from a photo the artist has done a pencil outline on the paper, sketching in the trees and the contours of the land. He has used a wash of Naples Yellow over the mountains. Some of the trees have been painted in Sap Green but others were left unpainted, giving the work a fresh, spontaneous look.

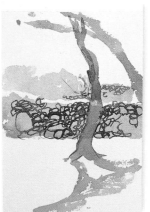

Monochrome study
Alizarin Crimson and Ultramarine have been mixed to create a mauve for use in this monochrome study. Subtle mixing of water and paint allows a variety of tones to be produced from one color.

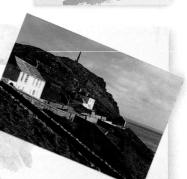

Initial washes
The picture has been broken into three areas of color and the details sketched in with pencil. Sap Green has been applied to the land and Ultramarine to the sky and sea. The clouds and the sides of the buildings have been left unpainted so that the white of the paper serves to create their shape and form.

STRETCHING PAPER

Unless your paper is very heavy, you will need to dampen, then stretch the sheet against a board before beginning to paint. This process is essential since it prevents the paper from buckling when paint is applied.

1 *Cut the paper to the size required, and soak it in a flat tray for a few seconds.*

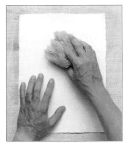

2 *Lay the paper on a board and, with a wet sponge, stretch it so that it is completely flat.*

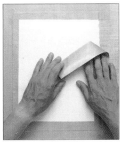

3 *Tape the paper to the board with gum tape. Make sure it is dry before applying paint.*

BRUSHSTROKES

The technique of watercolor painting depends on a careful blend of color pigment with water and the skillful use of a brush to carry this mix across the paper. Some brushes will hold water freely, allowing a broad sweeping application of color; others are delicate enough to draw fine dry lines. Apply a basic wash with a thick brush, then use smaller brushes to overlay colors and tones. Synthetic brushes are fine for most manipulations.

Paint a broad flat wash with a 1inch wash brush

A medium-size brush gives you a thinner line of wash

Use a fine rigger brush to paint a very thin line

You can use small round brushes to apply dry brushstrokes

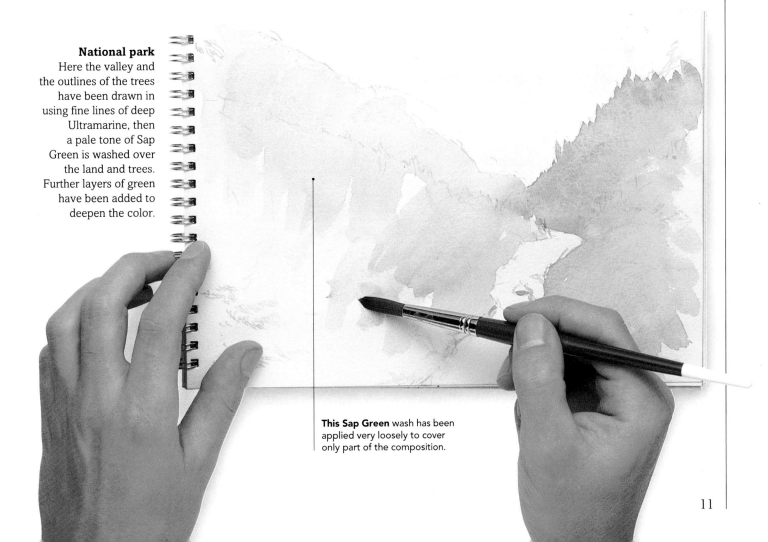

National park
Here the valley and the outlines of the trees have been drawn in using fine lines of deep Ultramarine, then a pale tone of Sap Green is washed over the land and trees. Further layers of green have been added to deepen the color.

This Sap Green wash has been applied very loosely to cover only part of the composition.

VENTURING OUTSIDE

PAINTING FROM A PHOTOGRAPH is a good way to practice handling watercolor. Once you have more confidence in your painting ability, you can venture outside. Look out your window or take a walk in the park to observe how the sun alters colors. Note the different hues of shadows. Become aware of the balance between trees, hills, spires, buildings, and the horizon. Use a viewfinder to help train your eye in composition and abstracting details of the landscape. Try sketching some of these scenes before you begin to paint.

CARDBOARD VIEWFINDER

You can construct a very simple viewfinder from two L-shaped pieces of cardboard. To use the viewfinder, hold it at eyelevel, about 6 to 12 inches away from you, and move it around until you find a pleasing composition. Adjust the viewfinder to make a portrait (vertical) or landscape (horizontal) frame. When you have decided on the focal point of your composition, judge the balance of the surrounding shapes, taking care that they form a rhythmical pattern that surrounds and enhances the main focus of your study.

From stiff card, cut two L-shapes to a length that suits you. A rectangular shape is more versatile than a square.

Arranged like this, the Ls can be adjusted according to the size of your subject.

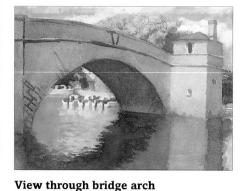

View through bridge arch
The bridge has been placed high on the paper so that its reflection echoes and accentuates the pleasing shape of the arch. The arch fills the width of the paper, making the view beneath it the focal point.

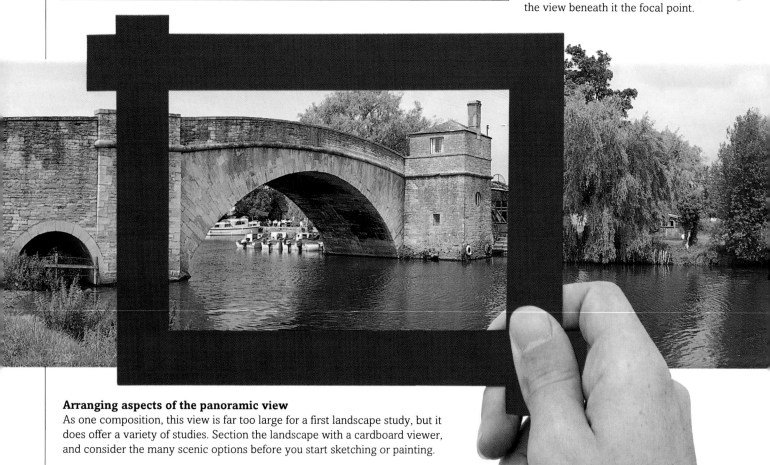

Arranging aspects of the panoramic view
As one composition, this view is far too large for a first landscape study, but it does offer a variety of studies. Section the landscape with a cardboard viewer, and consider the many scenic options before you start sketching or painting.

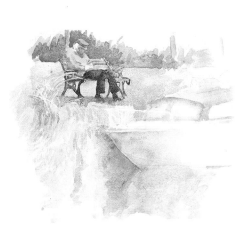

Figure study

This composition has a seated man as its focal point. He has been placed slightly off-center, an arrangement that allows the viewer a sense of the peaceful space that surrounds the figure. Note how the light falls on the back of the head and shoulders, in contrast to the shadows of distant trees and the reflection of the boat.

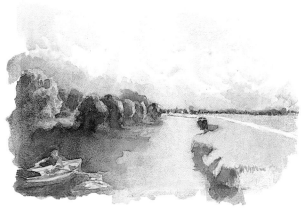

MEASURING

You can easily measure the height of the church tower by lining up a pencil with it at eyelevel. You can then translate the distance that the church tower occupies on the pencil to your paper. This method can be used to measure either horizontally or vertically in the landscape.

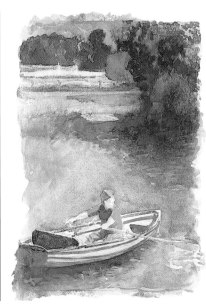

Landscape format

Here, the rowing boat has been placed in the foreground of the composition to provide the major point of interest. The rower is painted to give the impression he is moving across the picture. The river and path emphasize and continue the line of movement.

Portrait format

In this composition the man and boat are prominent, not only because they are in the foreground but because the light exposes them in clear tones while the encircling trees and water reflections carry darker tones in a subtle curve of shadow that enhances the boat.

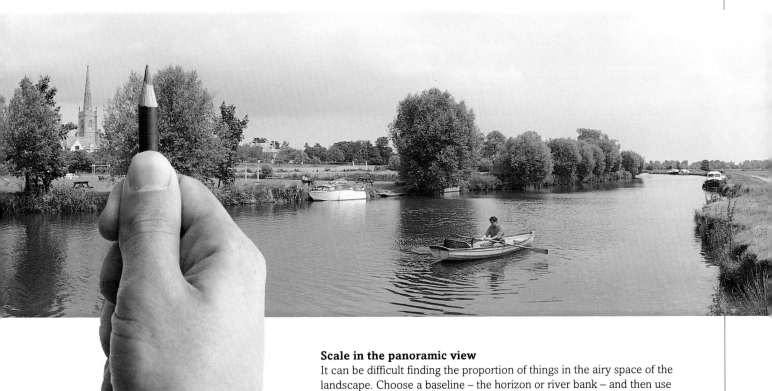

Scale in the panoramic view

It can be difficult finding the proportion of things in the airy space of the landscape. Choose a baseline – the horizon or river bank – and then use your pencil to measure the heights of trees and buildings from that baseline.

MONOCHROME STUDY

Color photograph
You can use a photograph for this exercise in monochrome. Try to look beyond the color and analyze the picture in terms of light and shade.

IN WATERCOLOR PAINTING the tone of a color pigment is altered by the quantity of water mixed into that color. Thus Ultramarine, when mixed with a good quantity of water, makes a pale tone of blue, while a more even ratio of water to Ultramarine will make a vibrant blue. Once a color has dried on the paper, it is not possible to lighten it. So, when you start working on a painting, keep the color mix very watery. To darken the hue, paint one wash over another until you find the tone you want. A monochrome (one color) study demonstrates this essential characteristic of watercolor. Follow the steps given here, using Raw Umber.

1 ▲ Draw the composition in pencil, simplifying the shapes of the trees and hills, ignoring details. Using a large wash brush, mix a small quantity of Raw Umber with water. Wash this pale tone across the sky, using a broad, sweeping stroke. Observe where the natural light lies, and leave those areas unpainted.

2 ▲ Select a slightly smaller brush, such as a No.10. Make a stronger tone by adding more color to the water. This darker tone is washed over the tree forms and foreground, but because light falls on the fields in the center of the composition, these are left unpainted.

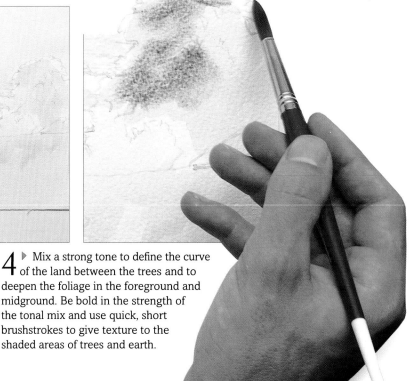

3 ▲ Mix a darker tone. Use this to define the foreground trees on the left and right, then wash the tone over the ground line between these trees. The same tonal mix can be used to block in the tree line in the middle distance. Use a wet brush and apply the color with smooth, regular brushstrokes.

4 ▶ Mix a strong tone to define the curve of the land between the trees and to deepen the foliage in the foreground and midground. Be bold in the strength of the tonal mix and use quick, short brushstrokes to give texture to the shaded areas of trees and earth.

APPLYING WASHES

A wash is a thin layer of paint on the paper. It is the basic technique of watercolor painting. A wash can form one smooth tone, or the color may be graded into various tones, depending on the brushstroke that is used. This build up of layers of wash controls and transforms the translucent colors that characterize watercolor painting.

Materials

Raw Umber

No.10 brush

1 inch wash brush

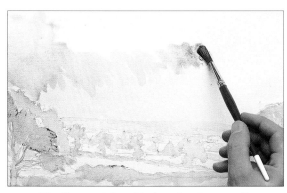

Adjacent washes
Paint a very dark flat wash with a very dry brush. Let the paint dry. In an adjacent unpainted area, apply a paler wash, pushing the paint toward and against the edge of the first application, but not over it. Repeat this process using successively paler washes. Each wash must dry before the next is begun.

Overlaid washes
With a thick brush, apply a light wash of uniform tone. Wait for it to dry. Using the same tone, apply a second wash but only partially cover the first area of wash. Repeat the process. You will see that the areas covered by layers of wash darken with each application. This method allows some control of tonal effects.

Graded wash
Apply washes quickly with a thick brush, working from the bottom of the page. Use a wash of almost pure color, then add layers of wash, each one more watery than the last. The top of the page will be light, and the base will be dark. Reverse the mix process – start watery and add color – to move from light top to dark base.

5 ▲ The first wash has dried on the sky area. Keep the tone used in Step 3, and use the brush in brief, jabbing strokes to illustrate the cloud formation across the sky. Where the first wash is not painted over, the tone will remain light, so this second wash will define the shape of clouds against the clear sky.

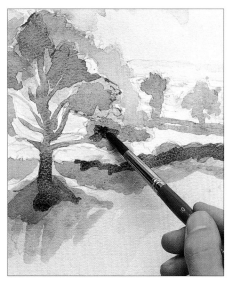

6 ◀ Mix a bold, deep tone, and with a fairly dry brush, start to paint in some details. Foliage can be given subtle tonal effects, while the branches and tree trunks are painted with a stronger mix of Raw Umber. You will see that the building up of particular areas and the emphasis on certain forms improves the perspective, as does the the increased contrast between light and shade. This contrast is fundamentally important in producing an effective monochrome.

7 ▲ Should you decide that parts of the sky need to be lightened, moisten the relevant areas with a wet, soft brush. Dry the brush, then use it to lift the newly wet color off the page, or use a sponge.

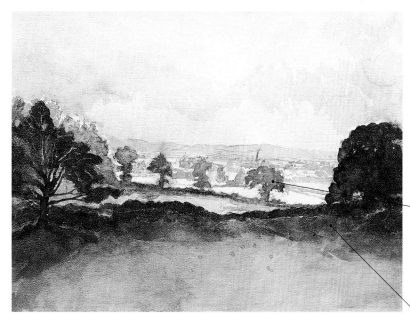

Tonal study
Layers of differing tones have been used in this painting to create, from one color, a sense of light and space.

These trees have been painted with a tone that defines the light on the fields beyond them, while emphasizing the dark trees in the foreground.

A light wash in the foreground is gradually covered with darker tones. These reflect the angle of the slope in the front of the composition.

MONOCHROME GALLERY

ONOCHROMES REVEAL the tones – the light and shade – of the world and so present a challenge to the artist's eye. Claude Lorrain observed complex tonal values, which he painstakingly reproduced in his works, while John Constable preferred to sketch his tonal paintings rapidly. Here are a range of monochromatic approaches.

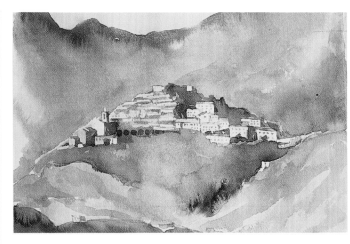

Ray Smith, *Monochromatic Study*
A distant village is seen as a group of cubes, clearly exposed in a pale light and forming the central focus of the composition. The artist has achieved a profound sense of space in his composition by his massing of dark tones, arranged to hold the lonely town within the grand scale of the mountains and valleys.

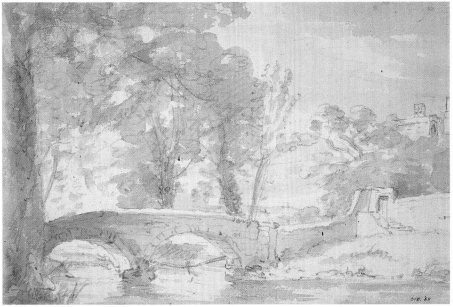

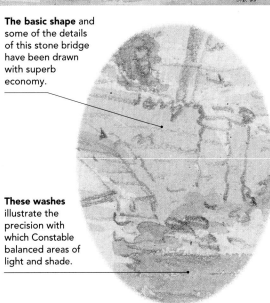

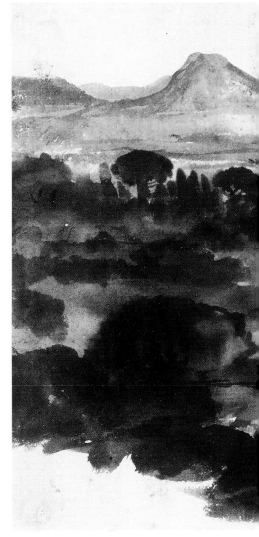

John Constable RA, *Bridge with Trees and Building at Haddon,* 1801
Constable preferred to paint outdoors where he could capture the fleeting effects of light. He favored oil paint, employing swift vibrant brushstrokes to capture color, but a gray and misty English morning of subtle light and little obvious color inspired this watercolor monochrome. A series of washes has been painted quite loosely, yet with masterly restraint, over a pencil sketch. The brushwork may seem slight, but there is not one superfluous brushstroke or tone in the entire painting.

The basic shape and some of the details of this stone bridge have been drawn with superb economy.

These washes illustrate the precision with which Constable balanced areas of light and shade.

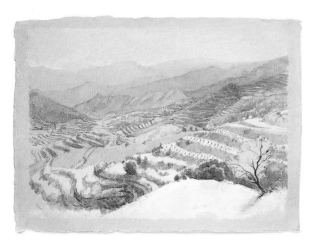

Tim Pond, *Mountain Landscape*

Composition and tonal values combine to make a powerful spatial statement in this landscape study. The rhythmical contour lines, represented by clearly contrasting tones, also serve to create space and distance. There is no obvious focal point, but the eye is led gradually to the deep shadows of the central valley before moving to the paleness of the horizon.

The artist used toned, textured paper to complement the gray of this monochrome. This detail shows the subtlety of the layers of wash.

Broad washes of warm, dark gray are merged into black. White gouache has been added to enhance areas of light.

Claude Lorrain, *View of the Tiber from Monte Mario,* **1640**

One of the greatest of watercolorists, Claude Lorrain introduced innovative wash techniques. In this powerful monochrome, the tonal values are very complex, portraying many changes of light within a vast and spacious landscape. Claude has left each wash to dry before applying the next, a system that let him build up, layer by layer, section by section, the most subtle variations in tone.

Bold, rich brushwork reveals a brilliant control over layers of wash. Study the tonal blending and note the inspired decision to leave the river surface unpainted.

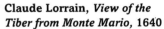

RECEDING COLOR

THERE IS A PAINTING CONVENTION, based on observation, that close objects have defined shape and detail and are strong in tone and color, while distant objects become weaker in color. This is known as "tonal recession." Landscape painting depends on this use of color and tone to create a sense of space. You need to learn which colors will recede and which you can use as strong advancing colors.

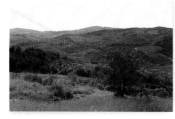

Vacation shot
Photographs make a good starting point and can help you remember a scene or decide on how best to compose your picture once you have returned to your studio.

Red and blue
A warm color such as red will appear to advance, while a cool color such as blue will appear to recede. Here, the red house stands out against a blue sky.

Red, yellow, and blue
Adding yellow alters the space. The advancing red recedes when juxtaposed with the warmer tones of the tree.

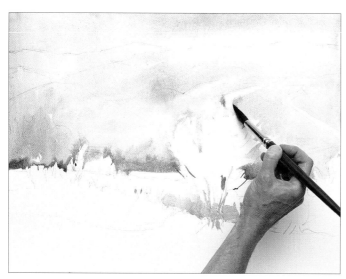

1 ▲ With a large brush, perhaps a No.14, apply washes of Ultramarine to the sky. The first wash must be almost pure color, the following washes have more and more water in the mix to achieve a dark horizon. Leave unpainted glimpses in the sky.

OVERLAYING COLOR

The transparency of watercolor allows the color of one wash to show through the layer painted over it. This is how tonal variation is achieved in this medium. Allow each wash to dry before applying the next, or else the colors will bleed or turn muddy.

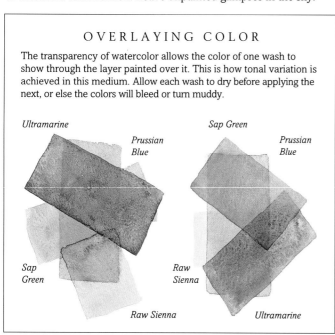

Ultramarine

Prussian Blue

Sap Green

Prussian Blue

Sap Green

Raw Sienna

Raw Sienna

Ultramarine

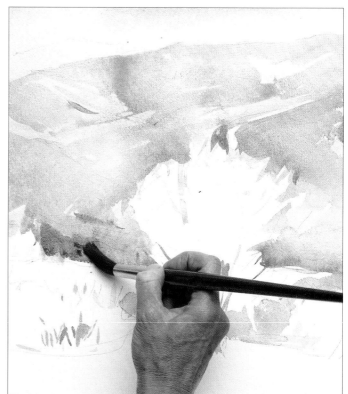

2 ▲ Let the Ultramarine wash dry. Prepare a watery Sap Green wash to represent the mountain shape. You will alter color and tone as you overlay the sky wash so, as the cool blue recedes, the mountain assumes form and height. The wash tends to "pool" when the brush is lifted off the page so use sweeping strokes.

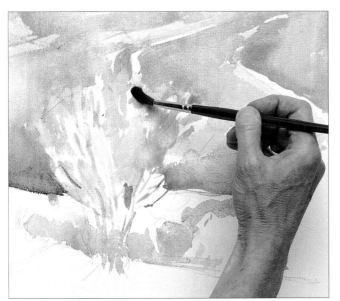

3 ◁ Allow the Sap Green wash to dry. Mix a Sap Green wash using less water than before. Choose a small brush, about a No.9, and with free strokes apply this wash to the tree. As it washes over the edge of the first green, a dark tone will outline the tree.

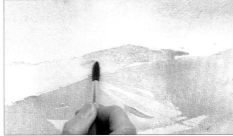

4 ▲ A pale wash of Prussian Blue is laid over the horizon just above the Sap Green of the mountains. This layer of Prussian Blue darkens the Ultramarine wash, but is still weaker in tone than the mountain Sap Green. See how this tonal variety in receding color gives a sense of space.

5 ◁ With a large brush, apply a watery wash of Raw Sienna to the foreground. Use broad brushstrokes. Let the wash dry. Mix a saturated wash of Sap Green and one of Raw Umber. With a fairly dry brush, add details to the objects closest to you – the foliage and the foreground.

Materials

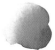

Prussian Blue

Raw Sienna

Sap Green

Ultramarine

No.2 brush

No.14 brush

Warm and cool color
The washes in the midground have been layered to develop an interesting range of cool and warm colors. Varying tones create perspective and give a spatial quality to the study.

Areas of the Prussian Blue wash have been darkened to suggest another mountain and to create another level of recession.

The receding depth of the painting has been created by a wash of Prussian Blue behind the tree.

Raw Sienna and Prussian Blue have been applied to the tree to give it detail and form. To add textural interest, some of the Prussian Blue was lifted off with a dry brush when the paint was still wet.

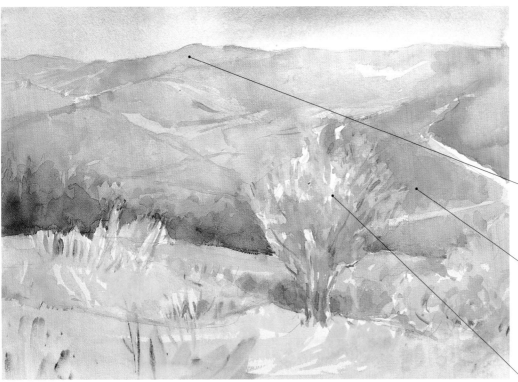

MIXING COLOR

THERE ARE THREE primary colors, red, yellow, and blue, from which all other colors are mixed. If you broke up light into color through a glass prism, you would see these primary colors, but you would also see the secondary colors, which are made by mixing two primaries, and the tertiary colors, a mix of a primary and a secondary. Every painter should understand this analysis of color and practice mixing new color. Also experiment by diluting your paints. The amount of water you use determines how light or dark the paints will appear on paper.

Viridian Green

Winsor Violet

Alizarin Crimson

Cadmium Red

Cadmium Yellow

Lemon Yellow Hue

French Ultramarine

Winsor Blue

Yellow Ochre

Burnt Umber

Lamp Black

Burnt Sienna

MIXING A BASIC PALETTE

This chart shows the variety of colors that can be achieved with the basic palette (*above*) of primary, secondary, and tertiary colors. Copy this chart by painting blocks of all the colors in the palette. Paint each color down the left and along the base; then proceed to mix each of the colors together in sequence. This chart will help you to learn the best combinations of colors and will prove invaluable as a quick reference guide for future paintings.

Basic color palette
It is hard to find pure primary colors that combine to make clean hues. This palette carries two blues, two reds, and two yellows, each a mix. It also has two secondary colors, violet and green, as well as three earth colors and black.

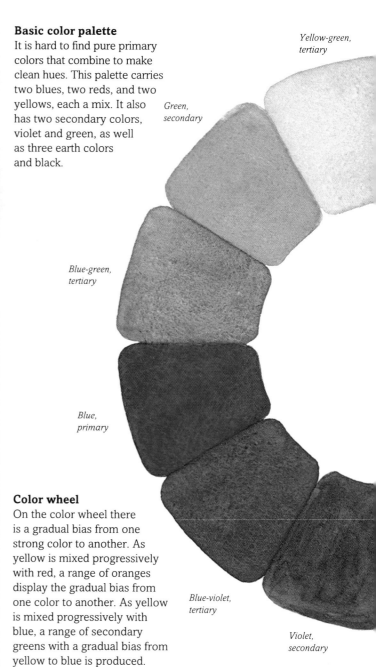

Yellow-green, tertiary

Green, secondary

Blue-green, tertiary

Blue, primary

Blue-violet, tertiary

Violet, secondary

Color wheel
On the color wheel there is a gradual bias from one strong color to another. As yellow is mixed progressively with red, a range of oranges display the gradual bias from one color to another. As yellow is mixed progressively with blue, a range of secondary greens with a gradual bias from yellow to blue is produced.

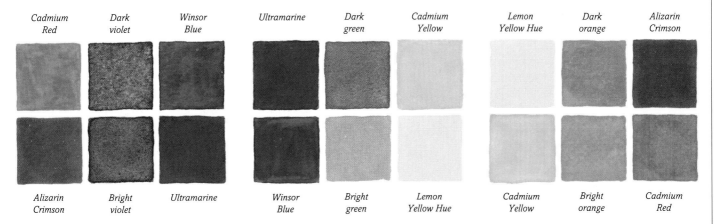

| Cadmium Red | Dark violet | Winsor Blue | Ultramarine | Dark green | Cadmium Yellow | Lemon Yellow Hue | Dark orange | Alizarin Crimson |
| Alizarin Crimson | Bright violet | Ultramarine | Winsor Blue | Bright green | Lemon Yellow Hue | Cadmium Yellow | Bright orange | Cadmium Red |

Mixing secondary colors

From the three basic primary colors it is possible to mix a wide range of secondary colors. As illustrated above, it is important to learn which combinations of primaries mix well to produce bright colors and which produce more muted hues. Winsor Blue mixed with Lemon Yellow Hue produces a pure, clear green whereas Ultramarine and Cadmium Yellow produce an earthy, muted green. When painting a landscape you may want to incorporate a wide variety of different secondaries to reflect the subtlties of nature.

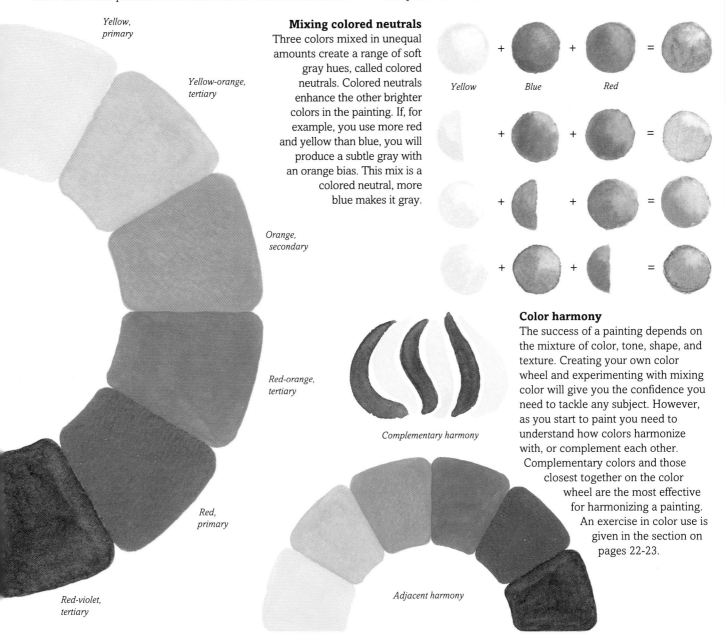

Yellow, primary

Yellow-orange, tertiary

Orange, secondary

Red-orange, tertiary

Red, primary

Red-violet, tertiary

Mixing colored neutrals

Three colors mixed in unequal amounts create a range of soft gray hues, called colored neutrals. Colored neutrals enhance the other brighter colors in the painting. If, for example, you use more red and yellow than blue, you will produce a subtle gray with an orange bias. This mix is a colored neutral, more blue makes it gray.

Yellow Blue Red

Complementary harmony

Adjacent harmony

Color harmony

The success of a painting depends on the mixture of color, tone, shape, and texture. Creating your own color wheel and experimenting with mixing color will give you the confidence you need to tackle any subject. However, as you start to paint you need to understand how colors harmonize with, or complement each other. Complementary colors and those closest together on the color wheel are the most effective for harmonizing a painting. An exercise in color use is given in the section on pages 22-23.

LIMITED COLOR

ONCE YOU HAVE MASTERED the principles of color, you will realize that it is not necessary to invest in a huge selection of color pigments – despite the fact that, as you look out the window or walk down a country lane, your eye is observing a multitude of colors and tones. In the exercise on this page, only seven colors are needed in your palette. By mixing these, you can greatly extend your color range. When you paint outdoors, consider the seasonal light and ensure your limited palette fulfills your needs – warm colors for summer, cooler tones for winter.

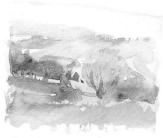

Planning your colors
Make a rough color sketch to work out which color mixes will work best, and where.

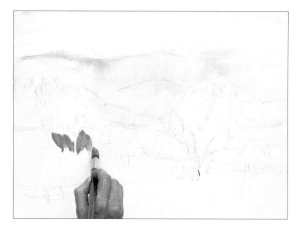

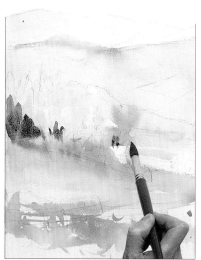

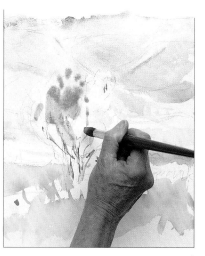

1 ▲ Apply Lemon Yellow to the sky, then Indian Red and Cadmium Yellow to the hills. Mix Cadmium Yellow and Alizarin Crimson for the foreground details.

2 ▶ Wash a watery mix of Indian Red and Viridian over the hills. With less water, wash an Indian Red and Viridian mix over the tree shapes in the mid-foreground.

3 ▲ Paint in the mountains with a mixture of Lemon Yellow and Prussian Blue. Then work a mixture of Viridian and Indian Red, with a bias toward the red, into the tree. The outline of the tree is a mixture of all the colors in the palette.

COLOR MIXING

In watercolor, you create your colors by judicial mixing, but the tone – that is, the intensity of the color – is determined by the amount of water that is added. Successful color mixing can be achieved through experimentation, but an informed choice of colors is an asset for achieving the most intense and effective of results. Practice the mixes given below, and as you progress you will learn to control the natural bias, mixing, for example, a bright red with a light blue to create a pale violet.

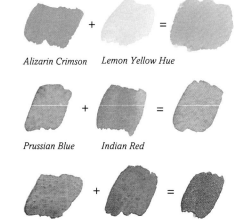

Alizarin Crimson	*Cadmium Yellow*	
Prussian Blue	*Cadmium Yellow*	
Viridian Green	*Alizarin Crimson*	

Alizarin Crimson	*Lemon Yellow Hue*	
Prussian Blue	*Indian Red*	
Alizarin Crimson	*Indian Red*	

4 ▲ While the last wash is wet, give detail to the foreground with a mixture of Alizarin Crimson, Indian Red, and Cadmium Yellow. Use a fine brush, and apply with quick, short strokes to indicate foliage.

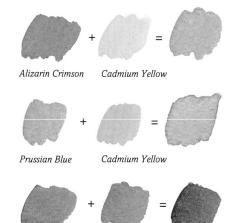

Materials

5 ▷ Paint a wash of Prussian Blue over the dry wash on the mountains. Wash the lower hills with Lemon Yellow Hue and then wash Prussian Blue over the top. Gently wash the upper hills with Prussian Blue and Lemon Yellow Hue.

Viridian Green

Alizarin Crimson

Prussian Blue

6 ▲ Paint a Prussian Blue wash on the mid-ground hills with a medium brush, perhaps a No.9. Use a watery mix to paint over the earlier, now dry, wash. This will bring the tree into sharper definition. Build up the tree's shape with a mix of Alizarin Crimson and Cadmium Yellow.

Cadmium Yellow

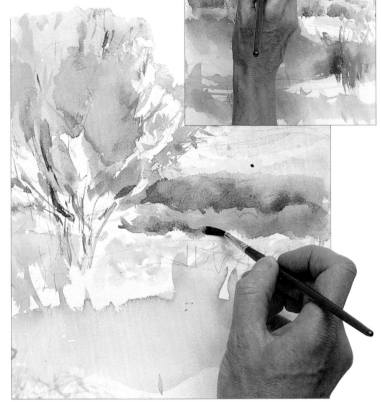

Lemon Yellow Hue

Indian Red

7 ▲ While the last wash of step six is still wet, paint a mix of Prussian Blue and Alizarin Crimson to the right of the tree. Also apply some Cadmium Yellow around the base of the tree.

8 ▷ Wait for all the washes to dry and then apply a thin wash of Raw Sienna with a large brush over the Indian Red, Alizarin Crimson, and Cadmium Yellow washes in the foreground.

Raw Sienna

Building up color
Control your brushwork to ensure the many washes build the right color in the right place.

Lemon Yellow Hue is lightly washed across the mid-range hill line over all previous washes, and also over any unpainted paper. This creates a tonal recession giving a sense of space behind the trees.

Brown-gray mixture (step 3) has been applied to give the nearby tree detail. Some of the paint on the tree has been lifted out (*see* p.19) to reveal white paper which has been painted with Lemon Yellow Hue.

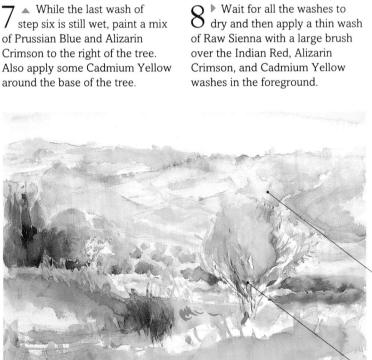

No.4 Synthetic Brush

No.9 Synthetic Brush

No.14 Synthetic brush

1inch synthetic wash brush

EFFECTIVE COMPLEMENTARIES

COLORS JUXTAPOSED WITH EACH OTHER cause differing effects, changing the quality of each color. For instance, there are pairs of colors that, when placed together, are in maximum contrast and mutually enhance one another: these are complementary colors. Look at your color wheel (*see* pages 20-21) to match the colors that face one another across the wheel. Orange and blue are complementary, as are yellow and violet, and red and green. This exercise demonstrates how to use and harmonize complementary colors most effectively.

Sketch of photograph
Choose a photograph that you like and use this to make a simple color sketch for the following exercise.

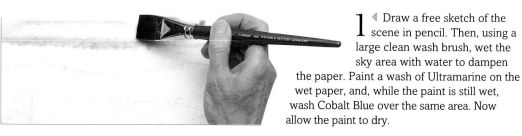

1 ◁ Draw a free sketch of the scene in pencil. Then, using a large clean wash brush, wet the sky area with water to dampen the paper. Paint a wash of Ultramarine on the wet paper, and, while the paint is still wet, wash Cobalt Blue over the same area. Now allow the paint to dry.

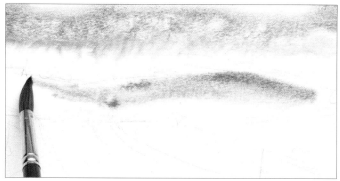

2 ▲ Mix Ultramarine and Alizarin Crimson to create violet. Then, with a large brush, wash the violet with bold brushstrokes on the mountaintops just below the skyline. Allow to dry.

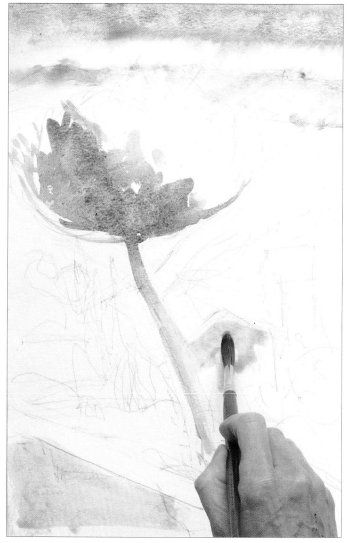

3 ▲ Pick out a few details on the top of the mountains with Cerulean Blue. Now apply a pale Lemon Yellow Hue wash below the violet mountains – complementaries side by side create a pleasing harmony.

4 ▷ When all previous washes are dry, wash violet into the tree. Now apply pale washes of pure Alizarin Crimson across the lower left corner of the page and behind the tree trunk.

PAINTING TREES

It is generally impossible for an artist to ignore the presence of trees in a landscape. It is therefore essential to concentrate some of your time on perfecting the basic shapes of a variety of trees. Sketch them on walks and study tree-tops you can see from your window. Draw the leaves and branches in isolation and look carefully at the light and shade held within the foliage. Practice this method of doing a color sketch.

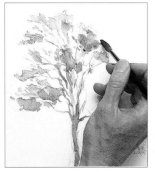

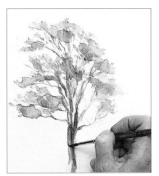

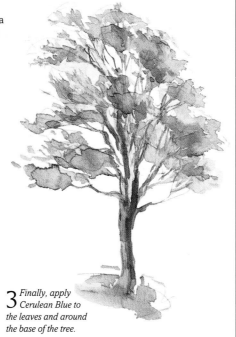

1 *Wash pale Cobalt Blue over a pencil sketch of the foliage and then paint Viridian Green shadows. Add a wash of Cadmium Yellow.*

2 *Strengthen tones with yellow and green washes. Mix Alizarin Crimson and Prussian Blue for the brown of the tree trunk and branches.*

3 *Finally, apply Cerulean Blue to the leaves and around the base of the tree.*

Materials

Cadmium Red

Cadmium Yellow

Prussian Blue

Ultramarine

Cobalt Blue

No.14 synthetic brush

1 inch wash brush

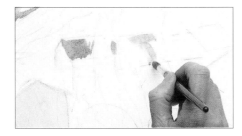

5 ▲ Create a pale orange wash from a mixture of Cadmium Yellow and Cadmium Red. Then, with a medium-sized brush, such as a No.9, block in the sides of the house beyond the tree.

6 ▷ Paint in the right-hand foreground area with a Cerulean Blue wash. When dry, paint foliage with Lemon Yellow Hue, then Cerulean Blue. This overpainting of transparent pigments will create green. Add small strokes of Cadmium Red for the flowers.

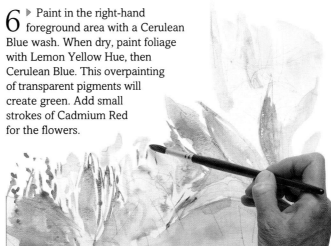

7 ▲ Paint Cadmium Yellow on the roof of the house beyond the tree and allow it to dry. Mix Sap Green and Lemon Yellow Hue to create a lime green, and then apply this to the top of the tree. This complements the violet (Ultramarine/Alizarin) wash.

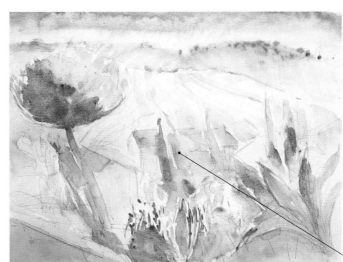

Bold contrast
The main areas of color have been mapped out, using complementaries.

The trees in front of the house have been painted with a mixture of Viridian Green and Prussian Blue. Cobalt Blue has been blocked in around this area and complements the surrounding orange.

8 ◀ Strengthen the tree color by applying Cadmium Red and Prussian Blue to the foliage on the left using a medium brush, such as a No.7. Mix Alizarin Crimson with Ultramarine, and Cobalt Blue with Cadmium Red, and work both of these colors into the trunk of the tree. Then apply Cadmium Yellow to the remaining foliage while the previous wash is still wet.

9 ▶ Define the trees at the front of the house by overpainting them with a strong wash of Cerulean Blue, and then block in the wall of the house visible between the trees. When dry, delineate the edges of the house by carefully applying a paler Cerulean Blue wash.

10 ▶ Paint a mixture of Cadmium Red and Alizarin Crimson over the area of Cerulean Blue on the side of the house. Then apply a darker wash of Cerulean Blue to the trees. This juxtaposition of complementary colors creates a vibrancy and an illusion of space between the house and the trees at the center of the painting.

11 ◀ Apply a pale Prussian Blue wash to the hills in the top right-hand corner of the composition. This will become a layer over the earlier Lemon Yellow Hue wash and will make touches of green, introducing a light recessive tone in the distance while hinting at the presence of foliage.

12 ▶ Lay Cadmium Red over the Alizarin Crimson on the leaves of the foliage in the right-hand side of the image. Work in some Alizarin Crimson, and then add a few final touches of Cadmium Yellow to create a strong orange-red. Take care over the wet washes if you do not want your colors to bleed.

Materials

Alizarin Crimson

Cerulean Blue

Lemon Yellow Hue

Sap Green

Viridian Green

Sponge

No. 7 sable brush

No 9 synthetic brush

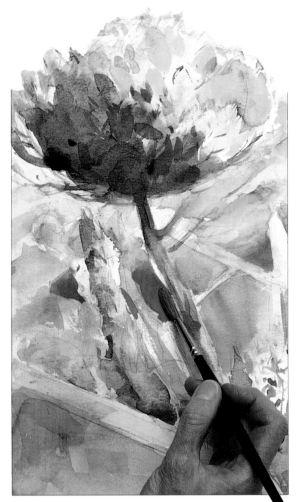

14 ▲ If you want to alter any details or areas on your painting you can wet the area with a brush and then lift the color off with a paper towel or sponge. This will lighten the color and may help restore balance to the composition. This technique can be used to modify a painting or more simply as a highlighting technique.

13 ▲ Apply a wash of Cadmium Yellow and Cadmium Red to strengthen the intense areas of color in the foreground and emphasize the pale hues in the distance. These touches of orange complement the blue, but be careful not to unbalance the composition with too much of one color.

15 ▲ Work some Cobalt Blue into the outlines of the leaves in the right-hand foreground, and lightly apply Sap Green within this outline. The scene appears bathed in sunlight as the strong high-key colors pick out and accentuate the foreground details of the foliage.

Layers of color

This painting has been built up with a range of complementaries. The strong tones in the foreground give way to the paler tones.

Alizarin Crimson mixed with Cadmium Yellow has been applied as a series of blobs across the mid-ground; Cerulean Blue dots have been added. These suggest rows of trees and terraces.

Alizarin Crimson has been applied to the roof. The windows have then been painted in with a wash of Cobalt Blue.

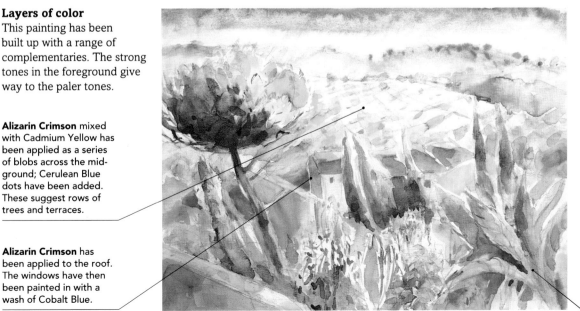

Washes of Cerulean Blue and Lemon Yellow Hue have been used to build up the area of foliage in the right-hand foreground.

GALLERY OF TREES

I T IS TEMPTING, when painting a landscape, to convey the presence of a tree with a simple sketch – a trunk, some branches, and an umbrella of leaves. Artists, however, are often faced with a great variety of trees, many of which are complicated and difficult to paint. Our illustrations show the different techniques used to create a detailed study of trees and a sketch that manages to suggest the movement of wind blown trees.

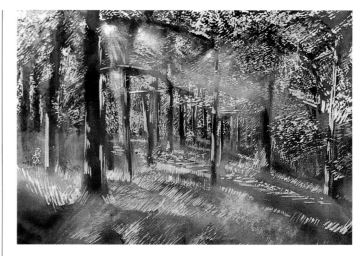

Philip Fraser, *Oakwood Wood*
In this painting, the artist was intrigued by the sharp tonal definition found within a grove of trees. He has masked out areas of the painting to preserve the white of the paper as shafts of pure sunlight penetrating the dense foliage. The dark trees are given further definition by a gradual build up of warm yellow washes. The artist's brushstrokes are short and delilineating to create a sense of sharp, intense light. This precise technique is exactly suited to the portrayal of forest light.

Once the initial broad washes of background color were dry, Varley used wet washes and short, deep brushstrokes for foliage. When these dried, he added another layer.

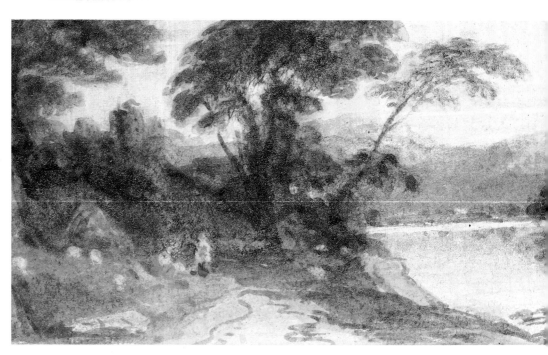

John Varley, *Landscape*, 1840
John Varley (1778–1842), through his teaching and books, did much to spread the popularity of watercolor in Victorian England. He knew how to manipulate washes to capture the slightest tonal change, and his brushwork was unerring – every stroke fits its purpose, whether it was to show smooth water or dry autumn foliage. This landscape study is about trees – how their branches break the skyline, how their shapes pattern water, and how their foliage dominates buildings.

Paul Sandby RA,
Landscape Study, c. **1750**
*Paul Sandby lived at Windsor Castle in
England, where he painted many fine studies of
the castle and its grounds. He was trained as a
topographer, but as he grew older his work
became more and more imaginative and
painterly. His impact, during his lifetime, was to
help watercolor emerge from its secondary role
into a serious medium in its own right. Although
the sky in this study (right) is masterly in its
range of tone and unexpected use of color, the
trees are the focal point. Sandby let his
background dry, then with practiced dexterity
sketched in his trees with a dryish brush.*

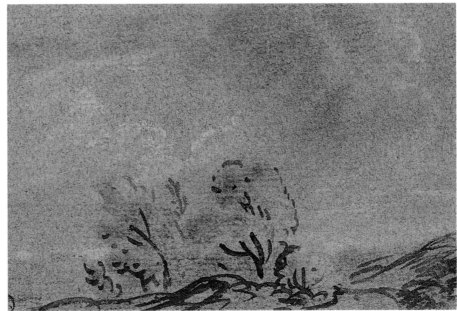

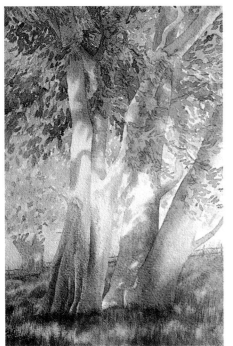

Julie Parkinson, *Sun-Dappled Beech Trees*
*This carefully observed tree study (left) shows a
remarkable control of the medium. The artist has
concentrated on the shapes of the trunks and the
texture of the smooth wood, but she has also studied
the movement of shadow around the cylindrical shapes
of the tree. Compare her technique of depicting the
tones in the grass and leaves with that of "Oakwood
Wood" illustrated opposite.*

Sharon Finmark, *Tuscany*
*In this painting (below), broad, bold washes
of complementary color were applied, and the
artist allowed bleeding between colors to mark her
tree line, yet these trees are not mere shapes
but identifiable evergreens and olives.*

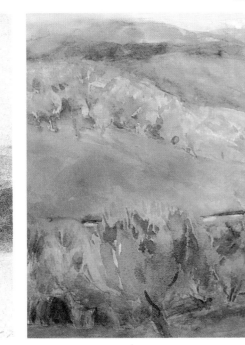

This detail reveals
the very controlled
tonal value of the
painting achieved
by an apparently
free, easy use of
brush and color.

COLOR UNITY

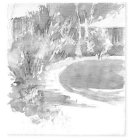

Color sketch
Make a sketch of a park or garden mapping out the main areas of color.

PAINTERS ARE AWARE OF THE "COLOR UNITY" in the landscape they are studying and how it alters with the time of day and the season. Color unity means that the predominant color, affected of course by light, is either "warm" or "cool." Obvious examples are that a misty morning is "cool," a sun-drenched beach is "warm." Colors with a red bias are warm, those of a blue bias cool, but green and violet contain both elements. Consequently, green and violet are used frequently, to harmonize a composition and provide color unity if placed judiciously with other complementary colors. The example given here is for a scene of cool color unity.

1 ◁ On the lawn, lay a wash of pale Cadmium Yellow with a medium-size brush. Overlay this with a mix of Lemon Yellow Hue, Prussian Blue, and a small touch of Cerulean Blue. Then wash Cerulean Blue with Lemon Yellow Hue into the trees. Apply a Cadmium Yellow and Permanent Rose mix to the tree foliage; overlay a mixture of Cerulean Blue and Cadmium Yellow on this to define the shapes of the leaves.

2 ▷ Wash a watery Permanent Rose on the flower bed. This is not a broad, sweeping layer, but one dotted here and there indicate flowers. Add touches of Ultramarine, letting the two colors bleed where appropriate. Wash greens on the foliage in the flower bed.

3 ▲ When all previous washes have dried, use a large brush to paint the sky with pale Prussian Blue. Use this mix to wash over a few of the branches and some of the foliage of the trees. Controlled brushwork is needed for this.

4 ▷ When the sky wash is dry, wash a mix of Lemon Yellow Hue and Prussian Blue across the trees. Then, using a medium-size brush, apply Permanent Rose with a small touch of Cadmium Yellow to the fence.

Materials

Cadmium Yellow

Lemon Yellow Hue

Prussian Blue

Cerulean Blue

Permanent Rose

Ultramarine

5 ▲ Using a slightly smaller brush, such as a No.6, paint the path gray with a mixture of Permanent Rose, Cadmium Yellow, and Ultramarine. Use a higher ratio of the yellow than of either the blue or the red, because this will create a warm gray.

6 ▲ Mix up a wash of violet using Permanent Rose and Ultramarine and then wash it over the fence, taking care to leave a white outline around the shapes of the trees and foliage. Allow this to dry before adding further touches of violet to give definition to details on the fence and to any areas of shadow.

Harmonious foundations
By this stage the basic color unity of the painting has been established. This unity will provide the foundation for a build up of washes and will add depth to the different tones and perspective of the whole painting.

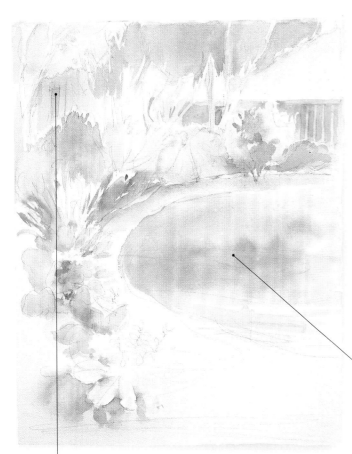

No.6 synthetic brush

No.9 synthetic brush

No.14 synthetic brush

The colors used for shadows on the grass echo those used in the flower-beds. These colors are the useful greens and violets, which are both warm and cool.

The garden shed is painted in the same colors as the fence, Permanent Rose and Cadmium Yellow, and violet has been used on the window.

7 ▷ With a medium brush, such as a No.9, paint a large shadow across the path and the lawn using violet. This enhances a violet-gray in the path and a subtle gray-green in the grass. To indicate sunlight, apply a Lemon Yellow Hue wash across the lower section of the grass.

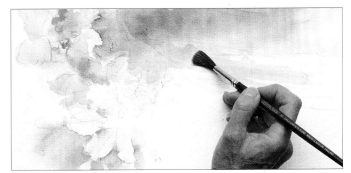

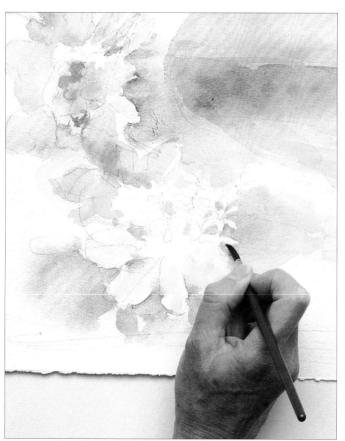

8 ◀ Using a medium brush, perhaps a No.6, paint the shadows of the foliage at the bottom of the painting – the green of the foliage tends toward violet in shadow. Add some touches of Lemon Yellow Hue to represent the reflected light of the leaves. The dark shadows, next to the lighter foliage, also help to reveal the form of the leaves.

9 ◀ With a slightly larger brush, darken the foliage by overlaying a Cadmium Yellow and Cerulean Blue mix on the pale Lemon Yellow Hue already applied. The colors used here enhance the yellow and blue mix that was applied previously.

10 ◀ Paint the flowers in the foreground with small delicate brushstrokes of a mixture of Cadmium Yellow and Permanent Rose, using a medium-size brush. The combination of colors in the composition causes the pink of the flowers to assume a yellow bias – now a pink/orange.

11 ▶ Now that the main areas of light and shadow have been delineated in the painting, you should start to build up the shapes in the painting through tone. Here, strengthen the tones of the trees by applying a mixture of Cerulean Blue and Prussian Blue. Building up the tones also helps to convey the form of the trees.

12 ▶ Apply more tone to the trunks of the trees. Mix Cadmium Yellow with Permanent Rose to create a subtle contrast between the cool color of the foliage of the tree and the warm color of the tree trunks. This is echoed by the contrast of the flowers and the foliage at the bottom of the composition.

13 ▶ Paint in the bushes just behind the path with a few small touches of Ultramarine and small amounts of violet, mixed from Permanent Rose and Ultramarine. This creates a strong contrast between the path and the bush, so will give dominance to the path's color and form in contrast to the paler tones of the background.

14 ▲ Paint small flowers into the foliage on the left of the composition by simply applying a few dots of violet adjacent to the surrounding yellow/green of the leaves on the bushes. Then apply small touches of Prussian Blue to strengthen the tones of some of the bushes. Overlay a Permanent Rose wash on the Cadmium Yellow foliage, to the left of the composition, to provide a yellow/orange note in contrast to the blue/violet of the flowers. Once you have established this subtle color unity, the addition of a few small touches of pink, orange, and red will enhance your composition. After all, an awareness of the color unity does not mean that everything in the landscape is reduced to the dominant hue.

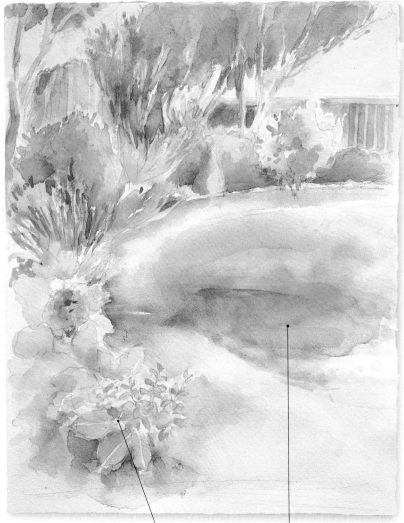

Combining harmonies
This project has focused on mixtures that are suited to a cool color unity. When you prepare your palette for outdoor studies, this form of color mixing will provide a good starting basis.

A few small brushmarks of Cerulean Blue are added to the foliage. This darker tone enhances the intensity of the pink in the flowers.

You can almost count the layers of wash that have gone into the foreground grass. The paler grass in the distance adds to the overall sense of perspective.

GALLERY OF LIGHT

PAINTERS BECOME OBSESSED with the quality of light, that mysterious element that alters color, form, and tone – or rather, causes an optical illusion of change. Turner was driven by the need to catch every nuance of change. Consequently he became one of the greatest of all watercolorists. The medium is ideal for rapid color work, and the innate translucency of the pigments is perfect for the reproduction of light.

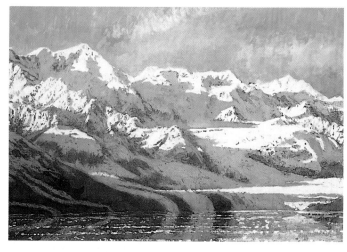

Tim Pond, *Alaska Sound*
This is a superb understanding of color unity despite, rather than because of, the obvious "cool" light. The artist could have conveyed this with very little effort, but he has given profound concentration to the elusive, changing tones of hard ice and scree, the soft-textured snow, and glassy water.

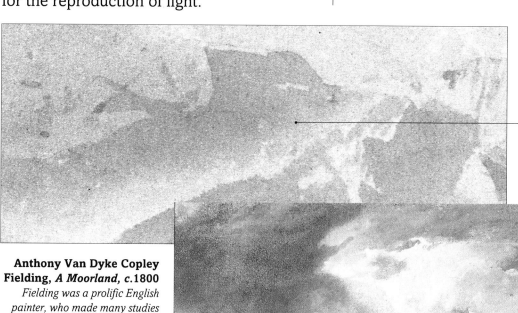

These washes reveal complex patterns of light – pale and dark areas of tone are cunningly mingled and have been painted with painstaking precision.

Anthony Van Dyke Copley Fielding, *A Moorland, c.*1800
Fielding was a prolific English painter, who made many studies of Wales and the Lake District, as well as numerous seascapes. This painting, technically a fine example of brushwork and control of paint, is nevertheless, slightly disconcerting. The composition is sharply divided between sunlit moors and bright craggy mountains, but the whereabouts of the source of the light, falling on both, is uncertain and the color unity fragmented.

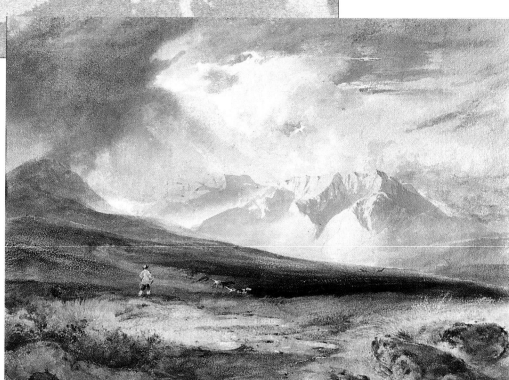

Philip Fraser, *Tiana*

In this painting of a Spanish town (left), Fraser has used the deep shadows found in the Mediterranean as the focal point of the composition. The cool tones soon wash away in a haze as powerful light encounters the shade; warm tones gleam in distant sun. The white areas have been "masked out" by applying masking fluid to those areas in early stages of the painting and then rubbing the masking fluid off once it and subsequent layers of paint have dried.

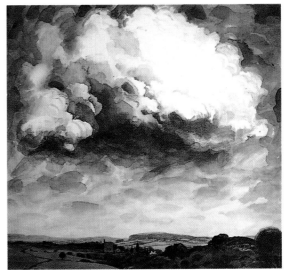

A high degree of luminosity is achieved with a limited range of colors, relying also on the brightness of unpainted areas.

Noel McCready, *Valley with Bright Cloud*

This composition (above) gives the sense of a huge spreading land, yet it is really a study of a cloudscape. The immensity of the sky looms in vivid tones of blue, gathering in darkening tones to crowd the luminous, pale vapor of one great cloud. The horizon is a dark narrow line. The authority of the tonal values and the thick color of the air make this a masterly statement on the illusion of light.

Paul Cézanne, *Montagne Sainte Victoire, c.*1905

This painting (right) is one of many that Cézanne painted of Monte Sainte Victoire. He was primarily concerned with structure, not the analysis of light. This interest in shape and planes gave him a keen perception of tones but often led him to ignore subtle, seasonal changes – although he did not deny color unity, as can be seen in this watercolor. This hot landscape is typical of his later works, described as "sparsely composed and open, permeated with a sense of light and space." The large areas of unpainted paper add to the sense of light.

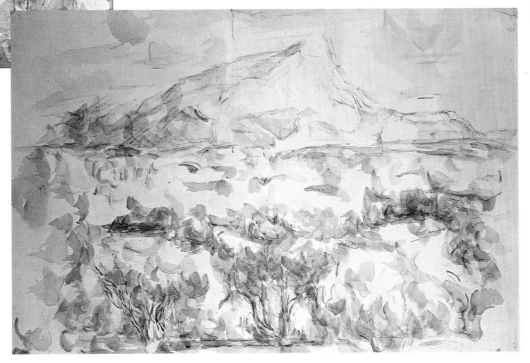

CREATING ATMOSPHERE

COLOR CARRIES A SIGNIFICANCE beyond its physical properties. It can be used symbolically and emotionally. The Virgin Mary is dressed in blue to symbolize purity and peace; warriors wear black and red to express anger and strength. Artists use color to reveal a mood or to evoke an emotional response from the viewer. Many abstract paintings are a color expression of emotion. In this example, we have chosen a mysterious moonlit night, dark, lonely, and majestic. The colors are brooding – deep tones of blue relieved by scattered notes of light. It is worth studying the methods described below in order to gain an understanding of how to create a sense of atmospheric color.

1 ▲ Sketch a brush drawing using Ultramarine on Turner gray paper. Apply an Ultramarine wash across the mountain range and the lake, ensuring that you leave the areas of light tones unpainted. The slightly tinted, gray paper used for this painting suits the "moody" range of colors, giving the light tones a muted intensity in keeping with the atmosphere being expressed.

2 ▲ With a very fine brush, use Ultramarine to sketch cloud lines on the unpainted sky area. Apply your brush freely in thick and thin lines. Let the paint dry. You can use a hair-dryer on a cool setting to speed up the process.

3 ▲ Move to the first wash on the mountain and lake area. Along the upper band, use a fine brush to add another Ultramarine wash. Vigorously rub the paint over the paper in loose, energetic brushmarks that make a pattern of changing tones. Allow the paint to dry.

4 ▶ Apply a touch of Permanent White gouache to emphasize the line of light on the water, the moon, and the light on the mountaintops; use a medium brush, such as a No.7. This will create sharp tones of light far brighter than the background gray paper.

PAINTING CLOUDS

Clouds do not really have color since they are merely vapor floating through the sky. As the light of the sun falls through the water of the vapor, it is reflected and refracted, giving an illusion of mass, form, and color. This exercise concentrates on how to capture this fleeting, elusive subject.

1 *Prepare a background wash of Cerulean Blue in pale layers, wet-in-wet in wide brushstrokes. Then sponge out some areas of the paint, making pale spaces to mark the cloud shape. Darken the tones of Cerulean Blue around the edges of these spaces.*

2 *Use a combination of Ultramarine and Alizarin Crimson; and Cadmium Red, Ivory Black, and Prussian Blue to bring tones to the cloud and sky. It is all too easy for watercolors to become muddy, so clean your brush between the application of each mix of colors, and apply the paint rapidly onto the wet layers.*

Materials

Ultramarine

Cerulean Blue

Alizarin Crimson

Prussian Blue

Ivory Black

Cadmium Red

Naples Yellow

No.2 synthetic brush

No.4 synthetic brush

No.1 synthetic rigger

5 ▲ With a large wash brush, paint pale Cerulean Blue across the sky area. Take care to sweep the brush evenly across the paper, particularly when the wash crosses over the line of the clouds and upper mountain line. Let the wash dry.

6 ▲ Still using a large brush, apply a wide, smooth line of Alizarin Crimson above the mountain range. This layer brings a subtle color to the clouds and an interesting range of tones.

7 ◀ Using a small brush, such as a No.4, apply an Alizarin Crimson wash to the lake in the foreground. You should use a very wet brush for this, applying a loose uneven line, to produce a series of watery tones that suggest the constant movement of water.

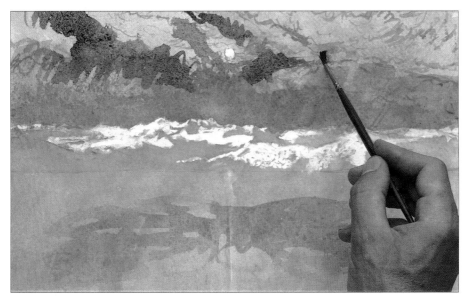

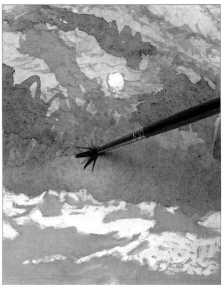

8 ▲ Continue to build up the clouds with a mixture of Prussian Blue and Ivory Black. Give this mixture a dash more of the Ivory Black than the Prussian Blue for a more intense hue. Using a fine brush, such as a No.2, make fluid, rhythmic brush movements as you add this dark tone to the cloud formation.

9 ▲ Develop further deep tones in the scene with the Prussian Blue and Ivory Black, but now use less water in the mix. Scrub the almost dry brush into areas requiring these deep tones. Small spots and specks of color from the previous layer will show through, giving a texture to the surface that is not achieved with an all-covering wash. This technique is known as "scumbling."

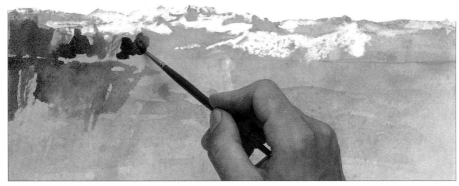

10 ▲ Paint the landmasses on the horizon of the composition with a mix of Alizarin Crimson, Prussian Blue, Ivory Black, and Ultramarine. You should also paint the reflections, which are the same color but of paler tone. Apply the colors on a wet brush, and again keep the brush clean. Observe the little glimpses of light tones. Keep them free of wash.

11 ▶ Develop the tones within the clouds by applying broad washes of a mixture of Ultramarine and Alizarin Crimson. You should sweep this over the washes of Ultramarine and Ivory Black previously applied to the sky. If you find that some areas are too dark in tone, lift the color off with a sponge. This can be done more easily when the paint is wet.

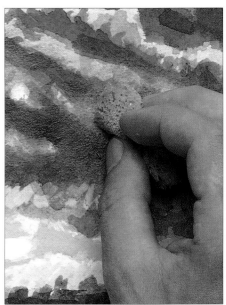

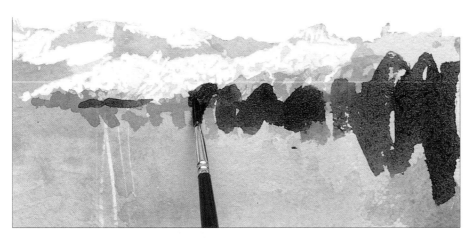

12 ◀ With a small wash brush, apply another wash of a mixture of Ivory Black, Ultramarine, and Alizarin Crimson over the two landmasses. You are now building up layer upon layer of color, making the tones deeper and increasing the brooding depth of this composition. Remember, that, each sweeping wash is pale with water – the depth of tone comes from the effect of layer upon layer of color.

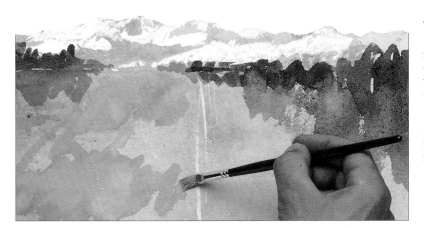

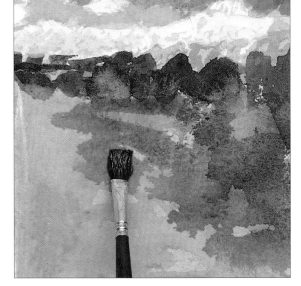

13 ◀ It is important to let your work dry before the next move. Now the light tones of moonlight should be washed in. Mix an Ultramarine wash with a touch of Permanent White gouache and cross this over the mountaintops. Use the same mix of colors to paint the broad sweep of moonlight reflected on the calm surface of the lake.

14 ◀ When the previous layer is dry, paint the reflections of the mountains on the lake surface. Mix Ultramarine and Alizarin Crimson and apply freely, while making sure the reflection matches the shape of the mountains.

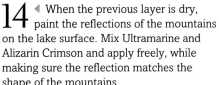

Materials

No.7 brush

½ inch wash brush

1 ¼ inch wash brush

15 ◀ With a fine brush, such as a No.2, paint a mixture of Permanent White gouache, Cadmium Red, Naples Yellow, and Alizarin Crimson just above the mountain line. Use a sketchy brush line, making rows of loose zig zags to let the previous layer show through. This tone represents the light that is reflected into the sky by the snowy peaks. Your final colors, though dark, should not be murky or muddy.

Atmospheric light
The light of the moon and the reflected light of the mountain peaks contrast very strongly with the dark tones of the lake and the lower mountain.

The moon has been defined with an application of Permanent White gouache. Ivory Black has then been touched on this, indicating the subtle tonal change caused by clouds.

This band of moonlight across the water has been given extra emphasis with a strip of White gouache. The opacity of the gouache captures the brightness of the light.

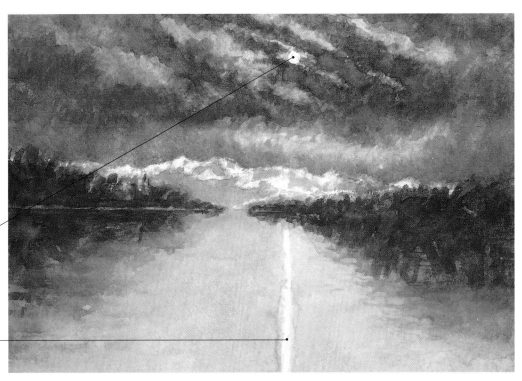

SKIES GALLERY

ARTISTS ARE FASCINATED by the changing panorama of the sky, but it is a subject that challenges every aspect of a painter's skill. Because clouds are both transient and of an unpredictable color, they are extremely difficult to record. Their tones are complex, as are the shadows they cast upon the earth. But these difficulties have neither frightened nor prevented artists from making studies of the sky. These pictures show different techniques used to capture its ever-elusive nature.

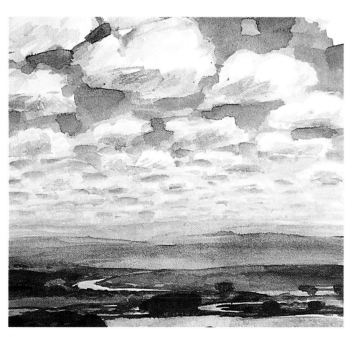

Noel McCready, *Autumn Landscape*
In this painting strong tonal contrasts cause the sky to advance visually toward the viewer. This use of tone creates the sensation of being poised high above the landscape. The dark details in the foreground add to the overwhelming vastness of the sky stretching into the distance.

Long horizontal brushstrokes are used for the smooth tones of light on the horizon, but a wide variety of strokes express the nature of clouds.

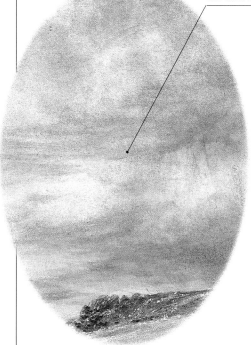

John Constable RA, *Old Sarum*, 1834
John Constable had a spiritual appreciation of nature, often using it as a metaphor for his emotions. This is visible in his work, particularly in his powerful and dramatic skies. This picture, produced by Constable after the death of his wife, reflects his solemn disposition at the time. Executed with infinite care, the painting symbolizes the defenselessness of man, with a lone figure under a huge, angry sky.

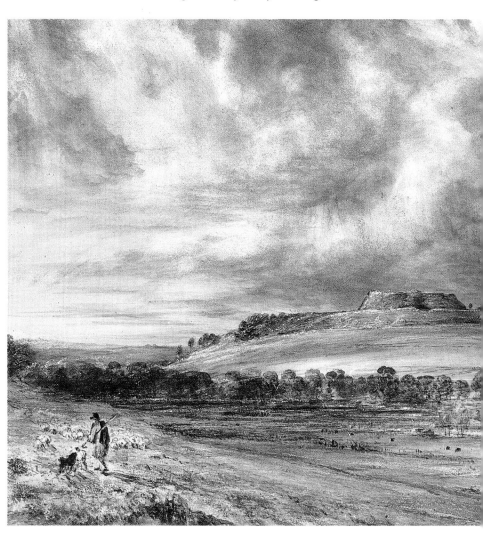

Julian Gregg, *Sunset, Alexandria*
This is a very bold use of tone from a contemporary artist. The drama of the sunset has inspired the artist to lay, in apparent abandon, one wash upon another. In fact, the colors have been applied with deliberation, designed to catch the turbulence of sea and sky in a fading light. The loose brushstrokes emphasize the stormy sunset mood.

The sun is a red of such strong intensity that the surrounding cloud is colored by it, as are the tossing tips of the waves directly below.

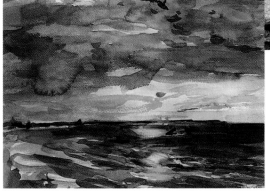

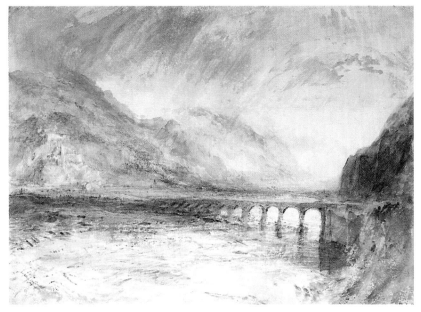

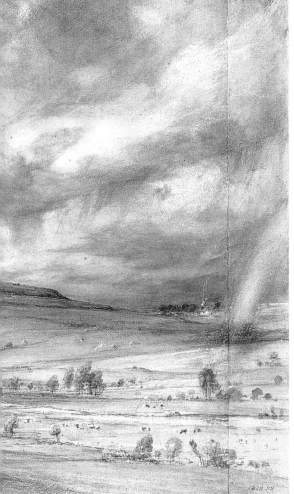

**J.M.W. Turner RA,
Bellinzona – Bridge Over the Ticino, 1841**
Turner's perceptive interpretation of light and his remarkably free brushwork inspired his fellow artist, John Constable, to write: "He (Turner) seems to paint with tinted steam, so evanescent and so airy." Light flows through this painting, falling from high sky to wide river. As a mature artist, Turner painted the world in abstract tones of light, and he is recognized as a radical genius whose original vision has altered our perception of the atmospheric power of light and color in the sky.

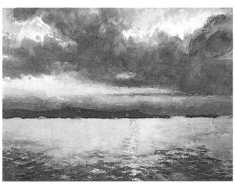

Tim Pond, *Untitled*
This sunset, although a wonder of color, is a reflection of a quieter climate than the sunset illustrated at the top of the page. The clouds here are calm, densely massed, and the water is a wide, smooth expanse of light. Changing tones of color are clearly defined. Brushstrokes are expressive but unhurried. This artist is an objective observer of the sea and sky, and his emotional statement is restrained.

SKETCHING BUILDINGS

MANY OF US MAY FEEL that our drawing ability is not strong enough to cope with the intricacies of a cityscape. We worry about perspective and all those details of road signs, neon lights, posters, traffic, and of course, people. Streets are crowded with detail and many buildings abound with architectural decoration. But it is not impossible to learn the basic rules of perspective, since the angular nature of buildings allows an easy freedom in interpretation. Reduce office buildings and stores to cubes; use color to reveal the mood of the street, not its physical reality; and use only those aspects of buildings that you want – abstract from the bricks and mortar the elements you need to express your own vision.

Perspective in a townscape

In this sketch a clever use of color and tone conveys a wealth of detail that, on closer inspection, has not actually been recorded. Dark shaded windows, the details of the balcony closest to the viewer, and the strong shape and color of the rooftops against a hazy horizon – all successfully record a view across a town. The sky has been painted with a wash of pale Cerulean Blue; the roofs with Cadmium Red; and the light playing on the trees in Naples Yellow.

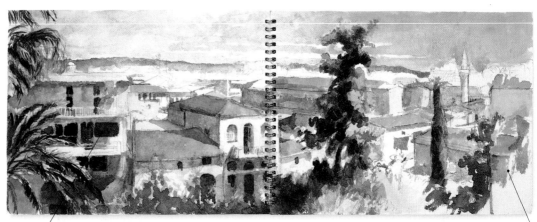

These very dark areas of shadow, used to represent windows and doors, are derived from a mixture of Ivory Black and Prussian Blue. This mix achieves a tonal quality suited to the intensity of the natural light in this scene.

Here, the Ultramarine wash has been left as a thin, pale layer, giving a tone of distance behind the Cadmium Red of the roofs, which are struck by the force of the midday light. The entire composition is light, fresh, and uncluttered.

Dark Alizarin Crimson, applied to the front of the building, gives an intense deep tone appropriate to deep shadow, yet allows us to discern the color and architectural details of the facade.

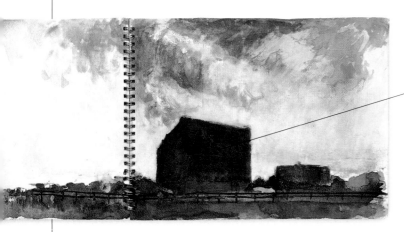

Buildings on a horizon

This composition has a low horizon, broken by the height of a building. The vanishing points are relatively close together, and the steep angles of the building give the picture a strong sense of drama. The fence in the foreground and brilliant light behind the focal point create dark tones in the foreground that emphasize the dominance of the building. The sky has been painted with Ultramarine and Lemon Yellow Hue, the building with Alizarin Crimson, mixed with a small amount of Ivory Black.

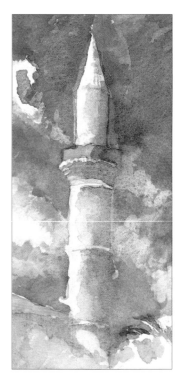

Cylindrical shapes

The cylindrical shape of this mosque tower may seem a daunting drawing problem. However, the tower is simply a series of parallel ellipses that are then joined by vertical lines. If you can find a similar building to look at, you will observe that the curves of the ellipses turn upward because your eye is below them. The shadows, too, circle around the shape. Once the geometry of the perspective is understood and the tonal qualities observed, you should feel quite confident tackling the subject.

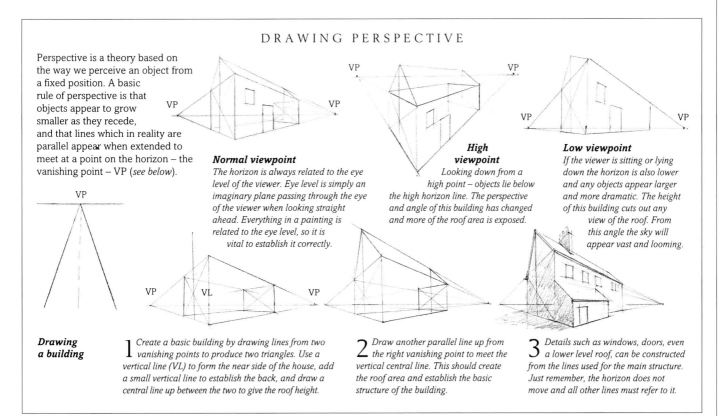

DRAWING PERSPECTIVE

Perspective is a theory based on the way we perceive an object from a fixed position. A basic rule of perspective is that objects appear to grow smaller as they recede, and that lines which in reality are parallel appear when extended to meet at a point on the horizon – the vanishing point – VP (*see below*).

Normal viewpoint
The horizon is always related to the eye level of the viewer. Eye level is simply an imaginary plane passing through the eye of the viewer when looking straight ahead. Everything in a painting is related to the eye level, so it is vital to establish it correctly.

High viewpoint
Looking down from a high point – objects lie below the high horizon line. The perspective and angle of this building has changed and more of the roof area is exposed.

Low viewpoint
If the viewer is sitting or lying down the horizon is also lower and any objects appear larger and more dramatic. The height of this building cuts out any view of the roof. From this angle the sky will appear vast and looming.

Drawing a building

1 *Create a basic building by drawing lines from two vanishing points to produce two triangles. Use a vertical line (VL) to form the near side of the house, add a small vertical line to establish the back, and draw a central line up between the two to give the roof height.*

2 *Draw another parallel line up from the right vanishing point to meet the vertical central line. This should create the roof area and establish the basic structure of the building.*

3 *Details such as windows, doors, even a lower level roof, can be constructed from the lines used for the main structure. Just remember, the horizon does not move and all other lines must refer to it.*

View between two buildings
This composition is based around the central vanishing point established by the converging lines of the road in the distance. The steep planes of perspective of the buildings echo this vanishing point and create a dramatic effect, because they appear to shoot toward the viewer. The viewpoint here is low, causing the buildings to tower into the sky, and the inclusion of the bridge increases this sense of height. The window details represented by darker tones emphasize the receding perspective and increase the illusion of distance.

As the buildings recede toward the horizon they become Ultramarine. A small touch of Alizarin Crimson has been used to reassert a sense of balance in the painting.

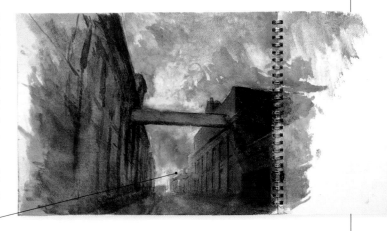

The basic shapes of the buildings are sketched in with fine lines of Ultramarine mixed with a small amount of Ivory Black.

As the buildings recede into the distance their colors become cooler and paler and add to the sense of perspective.

Sketching a skyline
The viewpoint in this picture is quite high and the horizon is low. The picture employs two-point perspective, with the vanishing points situated well off the page, and this gives the picture a restful atmosphere. The trees are Ultramarine mixed with some Naples Yellow to produce green. Pure Naples Yellow is also used for light reflected off the trees. Alizarin Crimson, as well as a variety of complementary colors, are used to paint the buildings. The whole skyline recedes gently into Ultramarine.

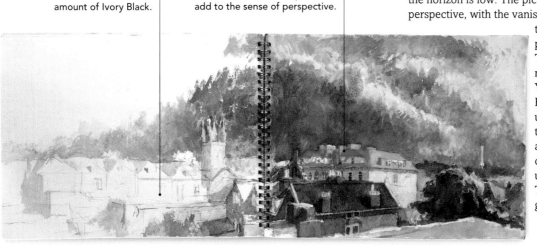

PAINTING THE CITY

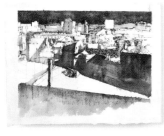

Monochrome sketch
To obtain the correct tone and sense of perspective in your composition, it is worthwhile to make an initial monochrome sketch of the cityscape.

LIKE A LANDSCAPE, a cityscape is a composite picture consisting of a series of individual components. To place these elements so that they form a coherent unity is the art of composition. However, a cityscape differs from a landcape in that it often contains many more components whose relationship to one another is complicated by a wealth of angular details, such as chimneys or rooftops. Because of the height of buildings in modern cities and their proximity to each other, large areas of a city street are in shadow during daylight, and the tonal values are complex. At night the city is transformed by electric light. Choose a range of colors that will capture city light, and apply them thoughtfully to create a bold, well-ordered composition.

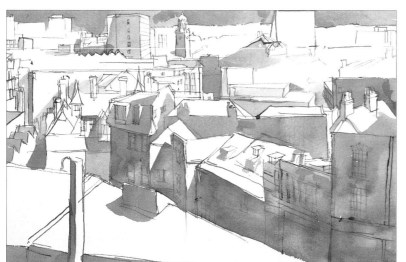

1 ◀ Paint the basic outline of this composition using Ultramarine. Paint in some of the fine detail of the cityscape, and lightly block in some of the main areas of shadow. Ultramarine makes a good initial ground wash for the range of night time colors that will subsequently be laid over it.

2 ▶ Block in areas of the composition with Alizarin Crimson using a medium brush. As with the previously applied Ultramarine, this color provides a solid ground for subsequent overlaid washes. Also overlay some Alizarin Crimson on the blue wash of the front of the house in the right-hand foreground. This will create a dark violet hue over which you can apply other dark washes. This technique of overlaying washes is ideal for developing shadows in the painting.

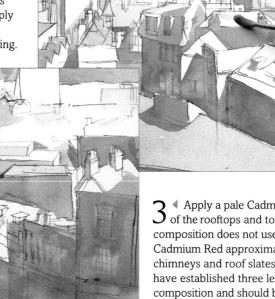

3 ◀ Apply a pale Cadmium Red wash to some of the rooftops and to the chimneys – this composition does not use naturalistic tones, though Cadmium Red approximates the natural color of chimneys and roof slates. By this stage, you should have established three levels of color throughout the composition and should be aiming to block in some of the color in such a way as to enhance the strong compositional style of the painting.

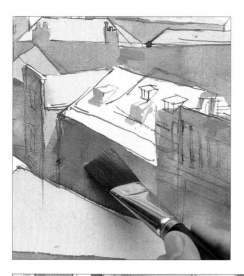

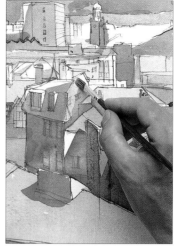

4 ◀ Continue building up the patterns of color in the composition. Using a large, perhaps 1¼ inch, wash brush apply Cerulean Blue washes along the horizon, to some of the buildings, and to the foreground in the left of the picture. Apply the same wash to the Ultramarine house front in the middle foreground of the composition to darken it.

Materials

Alizarin Crimson

Cadmium Red

Cerulean Blue

Naples Yellow

Ultramarine

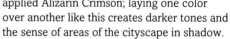

5 ▲ Using a smaller wash brush, apply Naples Yellow to some of the remaining areas of white paper. This will create the sense of sunlight falling on the sides of the buildings. Later you can add some lighter washes needed for pale tones in the composition.

6 ◀ Paint a second Ultramarine wash over the first with a small brush. Also, apply it to part of the building in the right-hand foreground over the already applied Alizarin Crimson; laying one color over another like this creates darker tones and the sense of areas of the cityscape in shadow.

7 ◀ Overlay Ivory Black on to some of the composition's light areas to create some of the darkest parts of the painting. These are mainly the windows on the buildings, which have been simplified in keeping with the style of the rest of the composition.

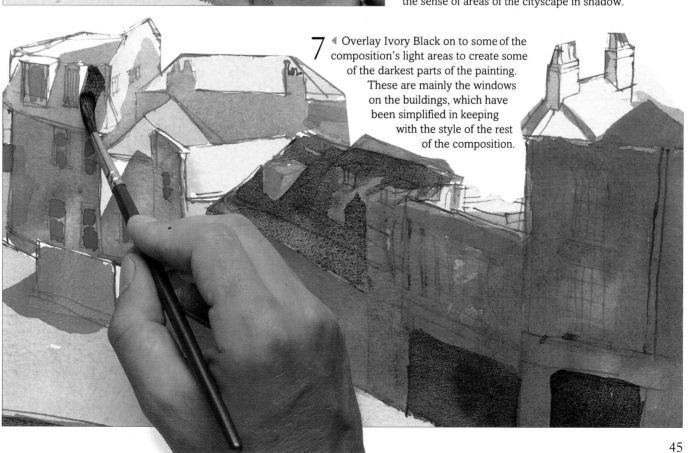

8 ▶ Fill in the remaining areas of white paper by applying a mixture of Cerulean Blue and Viridian Green. Use this wash to paint over some of the lighter Cerulean Blue washes. This dark green color complements the strong Cadmium Red, which is applied next and is the first in a series of darker tones to be used.

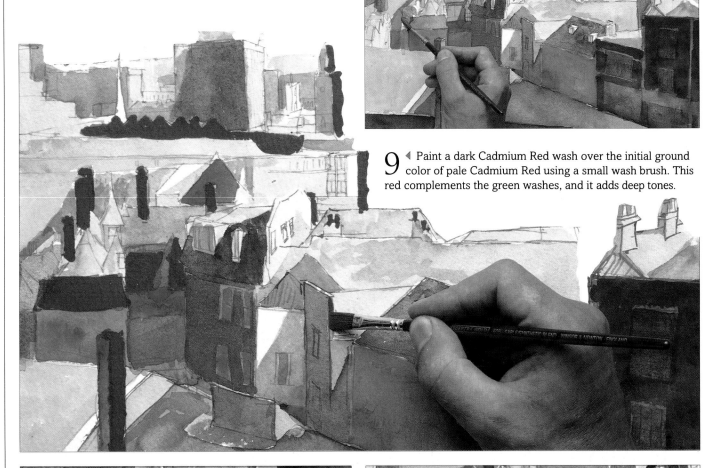

9 ◀ Paint a dark Cadmium Red wash over the initial ground color of pale Cadmium Red using a small wash brush. This red complements the green washes, and it adds deep tones.

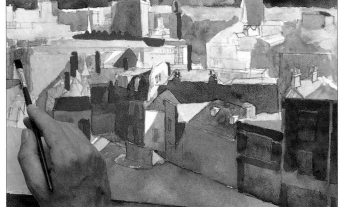

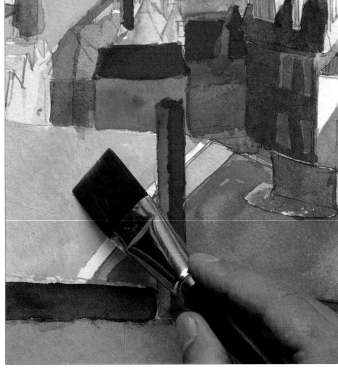

10 ▲ Block in the composition with dark colors. Here, you should apply a mixture of Prussian Blue and Ivory Black to darken some of the light Cerulean Blue washes. Be sure to keep this dark wash thin enough so as not to obscure the original Cerulean Blue washes.

11 ▶ Apply a wash of Lemon Yellow Hue over the Cerulean Blue area in the left foreground of the picture. This has the effect of creating a pale blue-green area, representative of light. Elsewhere in the composition, apply the wash over the Yellow Ochre roof-tops to create a similar effect.

12 ▷ With a medium brush, paint thick, dark washes of Ultramarine over the pale Alizarin Crimson and Ultramarine in the right-hand area of the painting. This will create swathes of shadow running across the composition, darkening it toward its main tonal bias. It will also help to make the painting tighter and more balanced.

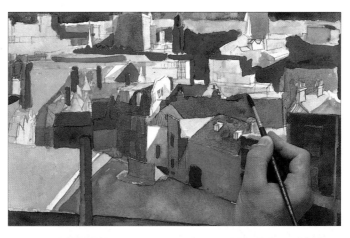

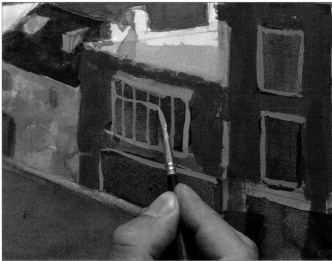

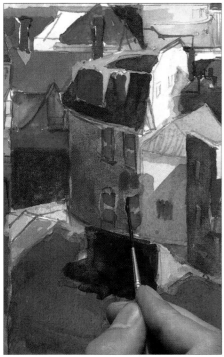

13 ▲ With a very fine brush, paint dark squares of Ultramarine over a lighter, dry Ultramarine wash to create the shapes of windowpanes and frames.

14 ▲ Using a medium-size brush again, apply Ultramarine and Alizarin Crimson, mixed with a Permanent White gouache for these window frames. Draw them in loosely around the dark squares of Ivory Black that have been applied for the windowpanes.

Light effects
Permanent White gouache has been applied to some of the remaining pale washes in the composition. Painted over Naples Yellow and Alizarin Crimson, it creates a textured effect in keeping with the overall style of the composition.

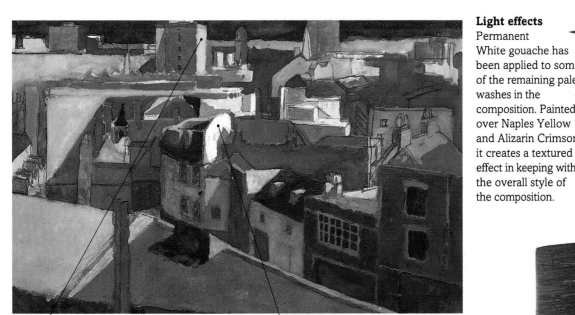

This complex cityscape uses bold planes of color to reflect the dramatic variations in light created by tall buildings and sharp angles.

The Permanent White gouache that has been applied to this area of Naples Yellow softens it and brings a tone of pale evening light into the picture.

Materials

Yellow Ochre

Ivory Black

Lemon Yellow Hue

Viridian Green

Raw Umber

No.4 synthetic brush

No.1 synthetic rigger

No.7 sable brush

¼ inch synthetic wash brush

1¼ inch wash brush

GALLERY OF BUILDINGS

CITIES ARE TRIUMPHANT PROOF that human experience has been transformed beyond its struggle with the earth. Cities are symbols of man's beliefs and dreams. The English Victorian William Holman Hunt painted Jerusalem, the Holy City, as a radiant city of light, a symbol of faith, but more personal symbolism has inspired other cityscapes. August Macke's vision of Tunis revealed, in a series of paintings, a view of the city that is both mysterious and sublime.

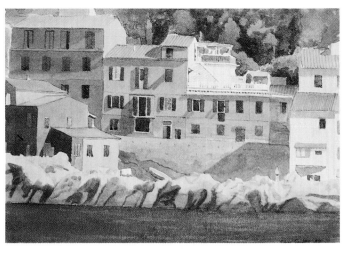

Ray Smith, *Marciana Marina, Elba*
This study was painted from the harbor wall facing the town of Marciana Marina on the Island of Elba. The buildings are geometric and regular, and interest is generated by the warm afternoon light enhancing the terra-cotta and golden colors of the facades on the buildings. The use of the complementary orange and blue hues expresses the harsh tones of the sunlight.

The colors of the dome of the cathedral, and of the city in general, carry a warm color unity that continues into the desert sands and background sky.

A meticulous handling of light can be observed in the tonal contrasts between the bleached-out walls and coppery domes.

William Holman Hunt, *The Holy City*, 1854
Holman Hunt has applied many layers of watercolor and gouache to create this dazzling view of the Holy City of Jerusalem. Some washes have been laid over each other while others have been juxtaposed against each other. Color contrasts are achieved through the use of complementary colors within the range of pale oranges and blues. Hunt has expressed the religious significance of the city with his inspirational use of light.

Tim Pond, *Untitled (right)*
The scene shows the variety of structures that may be present in a modern city: an old-fashioned wooden fence and rooftops in the foreground, with an apartment block in the background. The buildings are simplified until the composition is nearly an abstract of shapes and colors. Primary colors give an intense brilliance to the scene and bright light has been translated with the use of sharp Permanent White gouache. Texture is subtle and designed to give perspective.

A perfect study of tonal recession is demonstrated in this detail. Macke did not entirely abandon tonal conventions.

August Macke, *A Glance Down an Alleyway, c.* **1914**
In 1914, August Macke, together with Paul Klee, set off for Tunisia, where Macke painted his final works. In the same year, at only 27, he was killed in the World War I. In this study the street has been arranged with a geometric order. His palette is radical in its intensity and he experiments with the conventions of tonal recession. He has managed to hint at dark secrecy in the blazing heat.

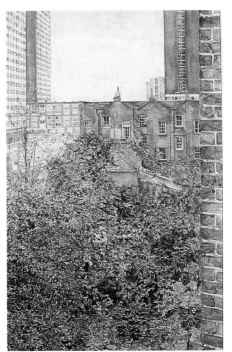

Judith Feasey,
Autumn, Norland W11 (above)
This painting evolved slowly, with tremendous care and patience in recording details. This contemporary representational painting uses watercolor in an unusual way, in that the sense of spontaneity usually associated with the medium is not present. However, the artist has used watercolor because of its translucence, and despite the careful labor of her brushwork, the lucid light of the autumnal scene remains.

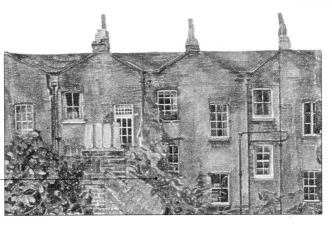

The artist has looked out her window to observe all the elements of the cityscape: crowded buildings, bewildering architectural detail – and foliage.

49

SKETCHING WATER

AN ARTIST MAY DECIDE that water itself will be the focal point of their painting, or that other subjects such as boats or wildlife on the water will provide the main interest. Either way, the element is a difficult one to capture. It is rarely static; it carries not only its own color and tonal values, but reflects those of the surrounding land, the sky, and even the land below the water. Any time spent studying and sketching water will prove invaluable when you start painting. Composition needs careful thought, especially when there are clear reflections. Your brushwork will need to vary to catch the movement and tones of the water.

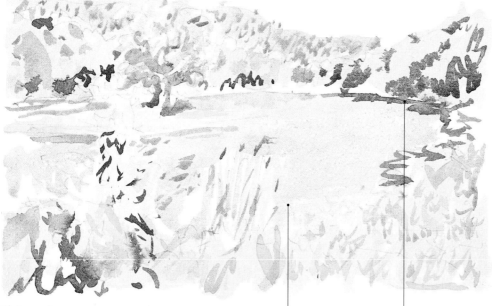

Sketching outdoors
Before you start a sketch, take time to observe the shape and form of the water and its areas of dark and light. These will be changing constantly, so use rapid sketches to record your impressions.

Flat sea
In this simple sketch of the sea, the sky wash is still wet as the sea wash is applied. When both have dried, the central horizon has been painted in very rapidly to create the impression of reflecting light. More washes have been allowed to bleed into each other to create a light, vaporous sky.

Dark Ultramarine has been painted into the foreground, its warm tones an important note in tonal recession.

A thin, rapidly applied wash of Winsor Violet creates the effect of light reflected off distant sea.

Cadmium Red bled into Winsor Yellow creates atmosphere; Manganese Blue overlaid along the bottom of the picture subtly blends the sea into the sky.

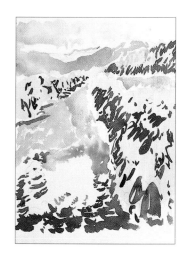

Slow-moving river
A large amount of white has been left in this painting of a river winding through hills. The tones of course lighten toward the distance, but the water has reflected a swathe of light in the foreground. This has been left unpainted.

Flat pond
An initial Ultramarine wash has been laid down to paint the surface of the still pond. Reflections are then added. Like shadows, reflections are affected by the direction and intensity of light. Part of the blue wash of the pond has been scratched out to show sprays of water and reflected light.

By scratching out the surface of the pond, the effect of dappled light can be created.

Light shadows here are similar in tone to the shadows found among the trees.

SCRATCHING OUT TECHNIQUES

Scratching out, also known as *s'graffito*, allows you to pick out highlights from a dry wash by scratching down to the white surface of your paper. It can be used to create the range of complex or simple light patterns that may be found on the surface of water. For a slightly different effect you can apply one wash over another, and then scratch the area you wish to define to the previous layer of paint – this will allow the first wash to show through the second. Here, three different methods create three quite distinct effects.

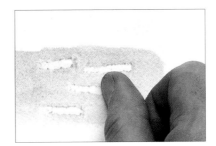

Thumbnail
Score thick, loosely formed streaks from the dry wash by using your thumbnail. These streaks are suggestive of the white crests of waves or breakers in the distance.

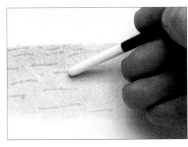

Scalpel
Use a scalpel to very gently scratch out parts of a wash. Here, this creates the effect of dappled light reflecting off the surface of water near the shore.

End of brush
Use the end of a brush to score lines across a wet wash. The brush makes grooves on the paper and the paint flows into it.

Lines of rolling waves
These waves are depicted as broken horizontal lines, the effect of which is created by painting over wax resist. The colors and tones do not simply recede here, but reflect the depth of the water and the shapes of the waves. Wide areas of white have been left to portray the pale crests of the waves.

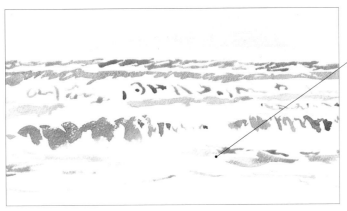

Pure Manganese Blue laid over a pale initial wash creates the effect of light reflecting off the shallowest water next to the shore.

Single wave *(below)*
A variety of brushstrokes are used to create a loose composition that moves from light to dark. Color has been layered along the bottom of the wave. Other parts of the wave have been painted in a single wash and dark spots added. The center of the wave is a very pale Cadmium Red.

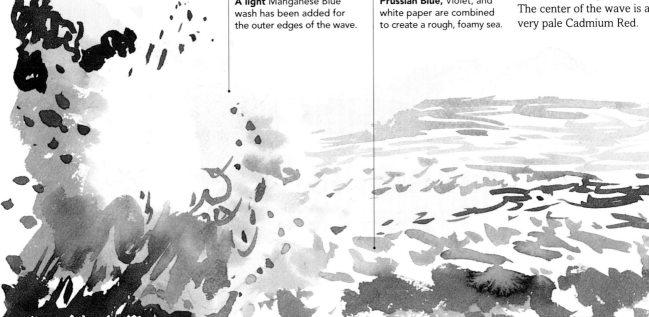

A light Manganese Blue wash has been added for the outer edges of the wave.

Prussian Blue, Violet, and white paper are combined to create a rough, foamy sea.

PAINTING WATER

Drawing your composition in pencil allows you to adjust the composition before painting. The boats have been placed to give distance to the perspective. Their angle causes the horizon to recede.

T HE ARTIST WANTED A COMPOSITION that was symmetrical, and he balanced the objects within it. The overall harmony of the colors also appealed to him. The picture was painted in January, early in the morning, and the color unity was cool. There are two boats, one in shadow and the other in light. The light and dark tones of each are reflected in the water, which the artist has tried to capture. Light is also reflected onto the boats and onto the buildings that line the harbor, which are painted in the same colors as the water. Though there are other objects of interest in this painting, the artist was intrigued by the water and its reflected light.

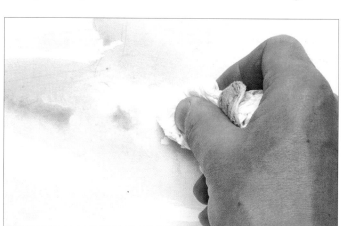

1 ▲ Start by applying a mixture of Ultramarine, Prussian Blue, and Yellow Ochre to the sky with a small wash brush – this creates a gray sky that will set the mood for the painting. Then start to build up the water by applying a mixture of Prussian Blue, Cadmium Red, and Ultramarine.

2 ▲ Apply a mixture of Cadmium Red, Ultramarine, Winsor Violet, and Prussian Blue wet-in-wet to show the water beneath the boat. Then partially lift it out with paper towel to allow some of the white paper to show through. This should create the effect of light reflecting off the surface of the water.

3 ◀ Mix Ultramarine with a very small amount of Cadmium Red and apply it to the foreground. This will create a darker underlying tone that, in the final composition, will contrast with the mid- and background water to create a sense of recession.

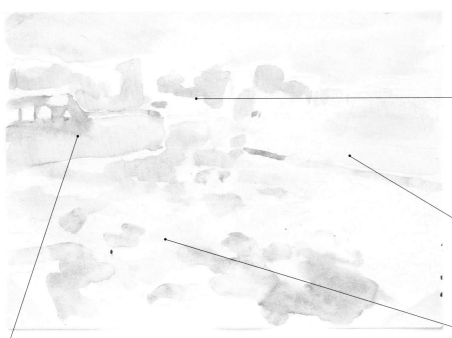

These buildings have been painted with Yellow Ochre mixed with a small amount of Ultramarine. Areas of white paper have also been left so that later washes can be applied.

The bottom of this boat has been washed with a mixture of Yellow Ochre and Ultramarine, which will give it a dark tone in the final composition. Winsor Yellow mixed with Alizarin Crimson has been used to paint the red line.

A wash of Ultramarine mixed with Cadmium Red (with a bias to red, creating purple) has been used to improvize the shapes and tones in the foreground.

Winsor Violet has been applied to this boat, painted darker at the top than at the bottom. Subsequent overlaid washes will reflect this tonal range.

4 ▲ Use your thumb to scratch out some of the paint. This simple technique will give the appearance of light reflected off the water's surface.

5 ▲ Consolidate both the light and the dark tones in the water by applying a mixture of Ultramarine, Manganese Blue, and Cadmium Red. This gives an impression of depth.

REFLECTIONS

Reflections are created when light rays strike water. They do not travel through water as they do in the air. Instead, they are deflected back, causing a mirror image of what lies above the water. The proportion of light that is reflected varies according to atmospheric conditions, the angle from which it is viewed, and the clarity of the water. Painting reflections is essentially about capturing the tone of light on water. Water has the effect of diluting color reflected from it, so the same hue is present, but of lighter tone.

1 *Carefully sketch the patterns that reflections make on the surface of the water. Then apply the area that has the most color. Here, it is the dark blue color of the surface of a river.*

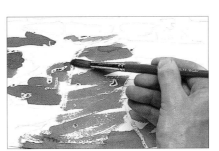

2 *Loosely block in some of the colors that you see reflected on the surface of the water. The objects will not always be recognizable due to the movement of the water and the play of light. However, note the blue, almost mirror-image of a boat in the top right-hand corner of the scene.*

3 *Finally, pick out those areas of color that display the greatest movement. Painted over the more stationary elements reflected in the water they will create a shimmering effect and will add to the overall impression of random movement and light.*

Materials

Cadmium Red

Alizarin Crimson

Winsor Violet

Ultramarine

Manganese Blue

Prussian Blue

Winsor Yellow

Yellow Ochre

No.11 synthetic brush

¾ inch mixed fiber wash brush

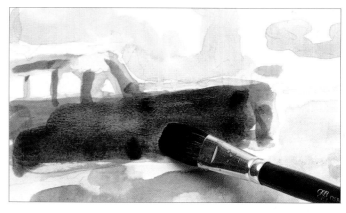

6 ▲ Mix together Winsor Yellow, Ultramarine, and Yellow Ochre. Using a large brush, perhaps a No.11, apply it to the foreground of the painting. Again, you should allow some areas of white paper to be left unpainted to create the effect of bright light reflecting back off the water.

7 ▲ With a small wash brush, build up the color on the boat on the left by applying an initial dark wash of Winsor Violet as under painting. You should then paint a mixture of Prussian Blue, Cadmium Red, and Ultramarine over this.

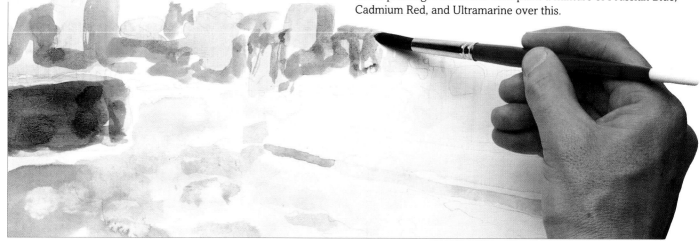

8 ▲ Mix Cadmium Red with a selection of blues and yellows to obtain a grayish blue color. Overlay this on to the buildings to create shadows. The color is similar to the colors found in the water and gives the impression that the buildings are dappled in light reflected from the water's surface.

Building shadow
Ultramarine and Manganese Blue have been applied to enhance some of the shadows on the water.

More gray-blue washes are added, this time with a bias toward Prussian Blue, to build up the shadows on the buildings.

Winsor Violet and some Cadmium Red are applied to the water, also to the windows of the boat above.

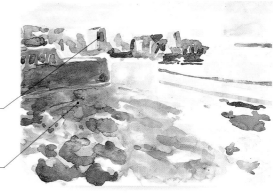

9 ◁ Paint reflections on the surface of the water with a mixture of Ultramarine, Prussian Blue, Yellow Ochre, and Cadmium Red. The color of the reflections corresponds to the boat above it, except that Yellow Ochre makes the reflections lighter.

10 ▷ Apply a mixture of Prussian Blue, Cadmium Red, and Ultramarine to the windows of the boat on the right hand. The color of the windows finds an echo in the range of colors that have been used so far throughout the composition.

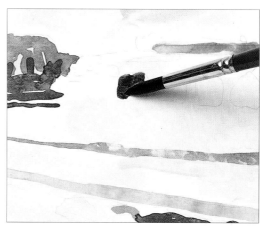

11 ▲ Remove some of the Yellow Ochre from the buildings with a paper towel. Then add some more gray-blue mixture. The final effect should be a balance of the light and dark tones that make up the play of shadow and light.

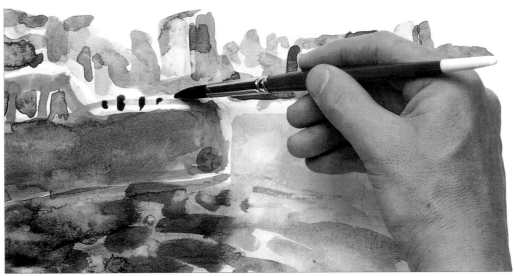

12 ▲ Paint vertical lines along the harbor wall using a mixture of Prussian Blue, Cadmium Red, and Winsor Violet. Though this is only a small part of the overall composition, it is an extremely important one. Because the composition as a whole tends to run along horizontal lines, the addition of vertical lines very subtly compensates for this and produces a more balanced picture.

13 ▷ To create the reflections of this boat's windows, apply a dark blue mixture of Cadmium Red, Prussian Blue, Ultramarine, and Winsor Violet.

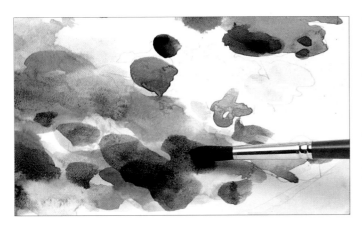

14 ◁ Continue working up the water until you feel satisfied with the end result. Continue to apply colors that follow the range of colors you have already applied. For example, mixes from Yellow Ochre, Winsor Yellow, Winsor Violet, Cadmium Red, Ultramarine, and Prussian Blue could be used to paint in the foreground of the composition to create a warm dark green.

Creating space
The artist has made a point not to overwork this painting in order to retain its light, uncluttered feel.

A mixture of Cadmium Red and Winsor Violet has been used to build up the shadows on the water even further.

As areas of color have been sponged out, the remaining paint has run together to create a complex yet subtle play of light in this part of the composition.

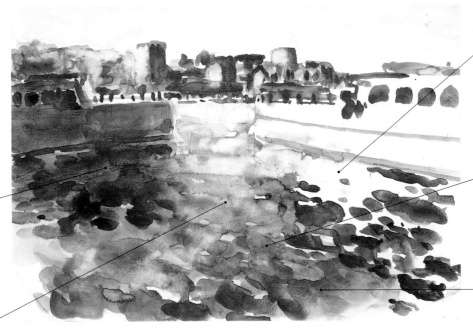

Large areas of white have been left to add to an overall feeling of light in the painting.

Winsor Violet has been laid over Manganese Blue and Ultramarine. Doing this will darken a light area, so that it emphasizes the surrounding tones.

This mix of yellow and gray blue has been built up in several layers to achieve the right balance of light and dark tones.

GALLERY OF WATER

UNTIL THE SEVENTEENTH CENTURY when Dutch painters such as Rembrandt (1606-69) and Vermeer (1632-75) began to paint the sea, European artists did not make serious studies of water. Turner, however, loved the sea for its light, and many watercolorists later shared this passion. Here, water has been painted by a variety of artists, each interpreting its complex nature in their own unique way.

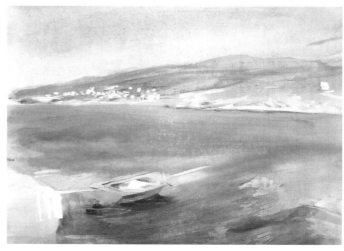

Philip Fraser, *Moored Boat (above)*
In this composition, strong, warm Mediterranean sunlight governs the use of color. The artist has managed to capture the very bright blue of the Greek Islands and the dazzling brilliance of the sea by applying, and slowly building up a series of intensely colored washes. Touches of white detail stress the intensity of light hitting the surface of the water.

The ripples on the surface of the water have been painted in with broad, flat brushstrokes. Stark contrasts in tonal value give a sensation of solitude and strong reflections of pure bright light.

Andrew Wyeth, *Morning Lobsterman, c.* 1960
In this painting, Andrew Wyeth captures the play of early morning light on water. This effect of light bleaching the sky and sea until they merge into one is created by using the same color for both. The foreground water is delineated by a very light application of tonal washes, and this creates the effect of clear, translucent shallow water. The color unity of this composition is cool. Wyeth's palette is extremely low-key, but very effective in recording a chilly morning and the dogged concentration of the lobsterman as he pursues his lonely work.

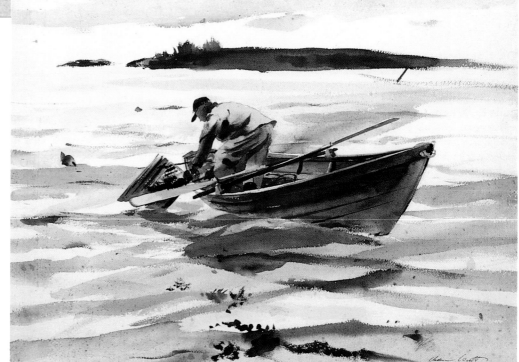

Winslow Homer, *Rowing Home*, 1890
Winslow Homer was a New England realist, whose main goal was to paint things exactly as they appeared. However, he also sought to imbue his paintings with a high degree of luminosity, albeit within a firm construction of clear outlines and broad planes of light and dark tones. Fascinated by water, he uses dense washes of warm color in this painting to suggest the soft, brilliant sunset on the surface of the sea.

Light coming from behind the oarsman casts him as a silhouette, while the dense brushstrokes, that he has been painted with, mirror those used for the sea.

This wave has been painted simply by overlaying touches of bright color on a darker wave shape; this depicts a small flash of light reflected from the wave's crest.

Julie Parkinson, *The Island of Scorpio, Lefkada (above)*
This picture has been painted from memory, with the artist trying to capture the feeling of tranquility that the island inspired. The sea has been painted to reflect the calm, warm, early autumn light and the dry olive-and-cyprus tree green of the Greek Islands. The painting has a luminous quality, which the artist has created by building up a series of dark washes on handmade, slightly shiny paper.

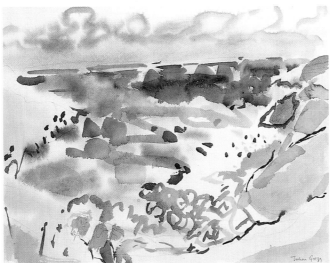

Julian Gregg, *Cornish Coast (left)*
Here, the sea has been reduced to large, colorful, almost abstract brushstrokes. Plenty of white paper has been left, and the loose arrangement of brushstrokes gives the painting its light, airy definition. The impression of depth has been created by carefully painting one color in front of another.

SKETCHING FIGURES

WHEN PAINTING A LANDSCAPE, you may want to include figures. These provide interest in a composition, also create a sense of scale. Before attempting a full-size composition, though, it is a good idea to make a few quick sketches. Use your family or look at photographs – most newspapers have good sports studies that show how bodies move. Your pencil sketches should be very simple, with details kept to an absolute minimum. When you start your color study, you can fill in the details of your figures with your brushwork and use color to give the body dimension through the tonal value, as with any other subject.

Pencil sketches
Pay attention to the overall form of the figure, rather than to detail. The position of a figure can change the dimensions of part of the body. For example, with a sitting figure, legs are slightly foreshortened.

Areas of dark and light on the figure correspond to the surrounding landscape. The colors representing light here are warm compared to those on the right of the composition.

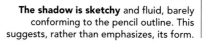

The shadow is sketchy and fluid, barely conforming to the pencil outline. This suggests, rather than emphasizes, its form.

Advancing figures
A mixture of Indian Yellow and Yellow Ochre is applied as an underpainted band that runs down the center of the figure and unifies any color and tone that is applied afterward. Positioning this figure close to the bottom of the paper gives a sense of her walking into the foreground. As a result of the direction of the light the figure is cast partially in silhouette, accentuated by strong areas of light and dark.

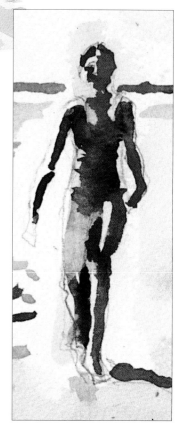

Figures in bright light
Because the light is so intense in this sketch, the figures are reduced to sketchy, almost impressionistic splashes of color – a lot of white space has been left, and color has been arranged around this. On the legs of the figure on the left, for example, the right leg is almost totally white, except for a very dark shadow running down the left side of the leg. This contrasts with the dark, warm tones on the other leg.

The figure has been painted into its own white space – a white border runs all around the figure. This slight tonal recession pushes the horizon far from the woman.

The footprints move closer together as they recede. The light and dark shadows inside the footsteps (see detail below) reveal the direction of the light in the composition.

Receding figures

The hazy colors and loose style of this composition reflect a mood of calm contemplation. The solitary figure moves through intensely bright space and the dark tone of her form stands out against the white sands. The footprints left in the sand decrease in size to accentuate the perspective of the figure moving across the vast beach.

The shirt has been loosely painted in with violet, and has then been partially dabbed out using a sponge to create an area running from a dark tone to a light tint.

The figures on the horizon have been loosely sketched and painted in the same color as the background (right). This conveys the diminishing effect of distance.

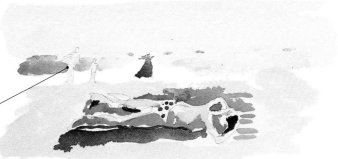

Close and distant figures

The shadow on the near side of the sleeping figure has been simplified and slightly extended. This, combined with the flat red of the towel behind the girl, has the effect of tipping the figure forward slightly. In this way the figure does not recede into the landscape, but lies comfortably in it. The spots on the girl's bathing suit emphasize the curvature of her body.

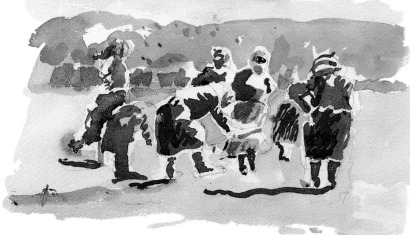

Group sketches

In this sketch the composition and use of colors reflect the mood that surrounds this group of women. The women are working in bright light and this has a strong influence on the colors that have been used. The definition of each figure is picked out in terms of the strong light and shadows falling across them (see detail). When a group of people are being sketched, it is important to pay as much attention to the space between the figures as to the figures themselves. The spatial relationships between figures will suggest how the relationship of color and light may affect the composition.

Pencil sketch
This rough pencil sketch of the composition has been drawn to run diagonally from left to right, with the receding landscape being framed by the cliffs.

TOWARD ABSTRACTION

S O FAR, THIS BOOK HAS DEALT WITH STYLES of painting that could loosely be called representational. They portray the landscape and objects in it in a such way that we can easily identify them. It is, however, true to say that any painting will involve a degree of reinvention on the part of the artist. Here, the artist has painted a seascape so that though water and beach are still identifiable, they have become abstract nuances of light and shadow. Figures have been included in this landscape, and these have been treated in a loose, abstract manner. Rather than being painted from photos or life, this picture was painted in a studio by amalgamating several on-the-spot sketches of figures, with a sketch of the landscape done some time before.

Reducing form
When drawing figures, you may find it helpful to see them in terms of rectangles or triangles. Here, the girl lying down forms an elongated triangle from her toes to her head, and her head is framed by the oval shape of her arms.

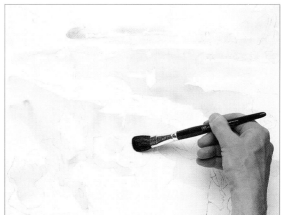

1 ◀ Before painting any washes, mask out some of the objects in the landscape with masking fluid – this will preserve the white paper from layers of washes. Paint three bands of color across the composition using a medium wash brush – Winsor Blue for the sky, Manganese Blue for the sea, and Yellow Ochre for the sand in the distance. Paint the foreground sand Cadmium Red, and apply Yellow Ochre to the figures at the left of the picture.

2 ◀ Mix some Winsor Violet and Ultramarine, and using a large brush, apply the mix with a zigzag movement, wet-in-wet over the Cadmium Red wash in the foreground. You should apply this wash quickly so that it conveys a sense of spontaneity. This darker area provides a point of interest and heightens the sense of perspective.

3 ▶ When all the initial washes have dried thoroughly, carefully peel off the masking fluid. The resulting hard-edged objects can then be painted in are now more defined in the landscape.

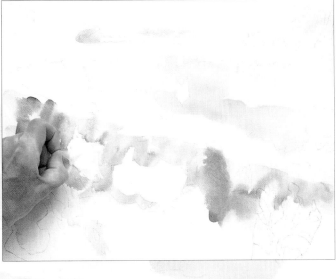

Cadmium Red

Ultramarine

Manganese Blue

Yellow Ochre

Winsor Violet

Winsor Yellow

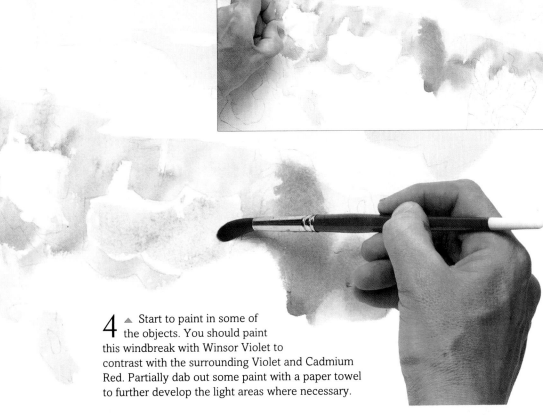

4 ▲ Start to paint in some of the objects. You should paint this windbreak with Winsor Violet to contrast with the surrounding Violet and Cadmium Red. Partially dab out some paint with a paper towel to further develop the light areas where necessary.

Extra fine pen nib

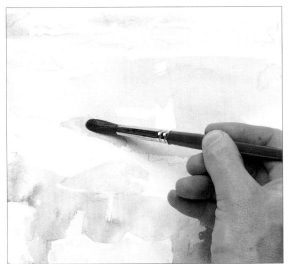

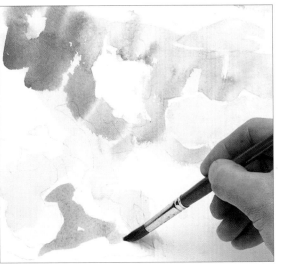

No.11 synthetic brush

¼ inch mixed fiber wash brush

5 ▲ Paint in the two umbrellas. Their shape is only suggested, and is recognizable. Paint the top umbrella with Cadmium Red to correspond to the wash that runs along the bottom of the composition; paint the bottom umbrella with Yellow Ochre so that it corresponds to the wash that runs along the top.

6 ▲ Loosely paint in a wash of Cadmium Red to depict the towel, which the figures, in the bottom left-hand corner of the composition, are lying on. This relates to the color of the wash above it, but should be painted slightly darker in tone. Like all the other objects in the landscape, the figures and their paraphernalia are reduced to the overall style of the painting – their form is suggested rather than literally represented.

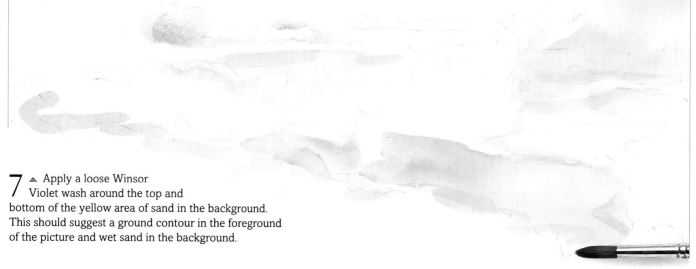

7 ▲ Apply a loose Winsor Violet wash around the top and bottom of the yellow area of sand in the background. This should suggest a ground contour in the foreground of the picture and wet sand in the background.

8 ◀ Draw in the outlines of the figures with a fine pen and watercolor to give them emphasis. The colors used here relate to the other colors in the composition but are stronger. Shadows are suggested with dark color, while Winsor Yellow suggests sunlight on the figure.

9 ▶ Apply just a few brushstrokes to the figures. Here, apply Yellow Ochre so that it loosely follows the shape of the figure. This helps the figure to stand out against the landscape.

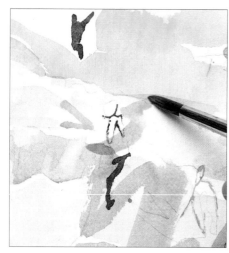

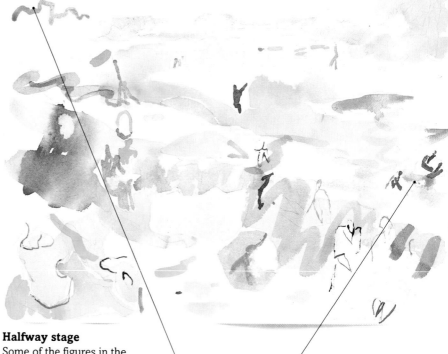

10 ▲ Paint a band of Yellow Ochre straight across the figure. Apply the brushstrokes in the same direction as those used in the rest of the composition to create a consistency and visual coherence within the painting.

Halfway stage
Some of the figures in the painting have been outlined in ink with a drawing nib, in a loose, unfinished style.

The cliff tops have been defined by free brushstrokes of pure Manganese Blue.

A Manganese Blue wash has been painted over wax crayon to create light on water. This technique is called "wax resist."

11 ◀ Maintaining this expressionistic style, loosely paint in the cliffs using a wash of Manganese Blue. Apply the paint very rapidly to create a series of squiggles, that subtly suggest the jagged, uneven rock surface of the cliff. These cliffs are a vital part of the composition, as they help to create a framework within which the other elements of the composition are able to work.

12 ▲ Use a mixture of Ultramarine and Winsor Violet to apply shadow to the overall composition. Here, shadow is applied to the windbreak in the center of the painting. When trying to place objects in a landscape, it is important to observe the tonal qualities. Study how the light falls at different times of day and consider how this affects your composition.

13 ▶ Apply shadows to the figures in the left-hand corner of the composition. The color used for the shadow is echoed by the colors that have been used elsewhere. When planning your composition, check that shadows will not disturb the color balance. If necessary move the object that causes the shadow or lift it out of your study using a wet sponge.

Adding abstract marks
A variety of colorful dots and blobs have been dropped into the composition in a random manner. On the yellow sand in the background they are a mixture of Cadmium Red and Winsor Violet, and on the sea they are Prussian Blue.

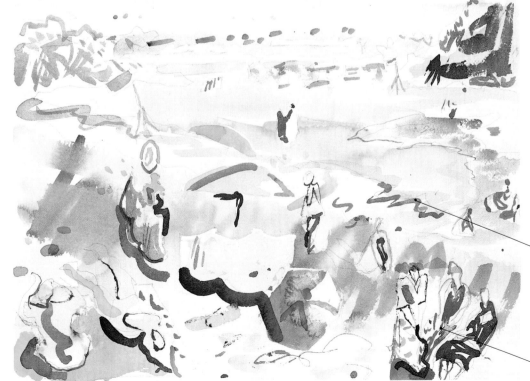

Overall in the painting, the artist has created the effect of the paint simply adding substance to the pencil line drawing.

The artist has left some of the figures unfinished, and this retains the air of spontaneity created by the brushwork.

ABSTRACT LANDSCAPE

PAINTING STYLES MAY BE LOOSELY DIVIDED into two very broad categories: representational, which reproduces the visual world as we see it, though not necessarily with photographic reality; and abstract, which does not convey the visual world but makes an intellectual or emotional statement in color. Painting a landscape as an abstract is to create a composition of colors and shapes evocative of the actual landscape. Here, the artist is inspired by the immensity of nature and singles out landmarks that capture the sense of scale and which move him. The artist modifies what he or she

Brushwork
Brush technique is integral to the look of the painting, so use your paintbrush rapidly and with confidence.

sees, and then incorporates it into abstract studies that suggest the feel of the natural world as he or she perceives it. The artist uses the landscape as a springboard to express feelings: "The landscape is a backdrop, upon which I can project, and reflect, my internal subconscious."

1 ▲ Apply a wash of Ultramarine to the paper with a large wash brush. This is the first brushstroke of the composition and as such will govern all subsequent brushstrokes. Do not plan, but allow the process of applying the paint to lead you. The amount of paint on the brush will dictate the intensity of colors on the paper and consequently the equilibrum of the whole painting.

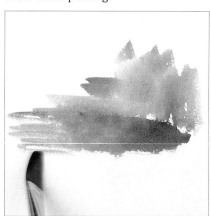

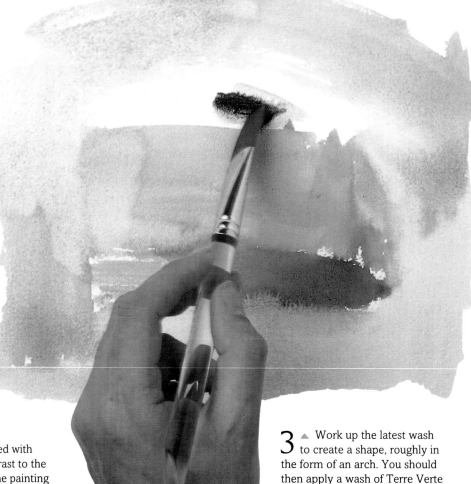

2 ▲ Apply a lighter wash of Turquoise mixed with a small amount of Cadmium Red. In contrast to the darker tone below it, the tone of this part of the painting is consciously lighter. Next, paint the dark tone – apply paint to this until your brush has no paint left on it.

3 ▲ Work up the latest wash to create a shape, roughly in the form of an arch. You should then apply a wash of Terre Verte with a touch of black to fill in the area of white space in the middle.

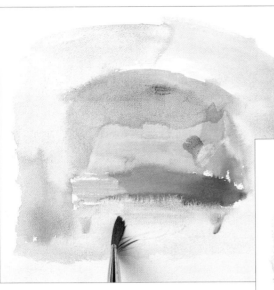

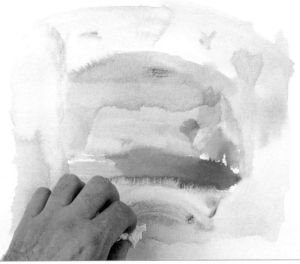

4 ◀ Run this wash of Terre Verte into the initial mixture of Cadmium Red and Turquoise. Then apply Terre Verte along the bottom of the painting and also use it to paint in the small abstract marks that could represent trees. However, in keeping with the painting, the form of these should be deliberately vague.

Materials

Cadmium Red

Rose Madder

Terre Verte

Ultramarine

Cobalt Blue

Black

Turquoise

5 ▶ Using Terre Verte, paint two large "trees" at either side of the abstract structure in the center of the composition. Also paint in some smaller ones. Paint in an arch by applying an Ultramarine wash along the bottom of the composition, and then scrub it out with paper towel. This will remove paint from this area and allow the paints to mix into each other.

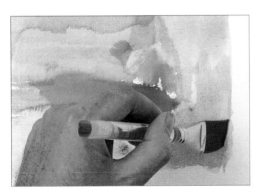

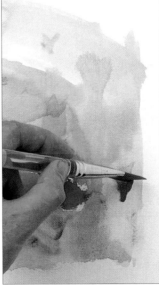

6 ◀ Apply a further wash of Ultramarine to the right-hand corner of the painting, and then work this up with a wash brush. The way that you control the flow of paint on the paper plays a major role in creating the painting's qualities of color, tone, and mood.

7 ▲ Overlay a Cobalt Blue wash on the worked up area of Ultramarine. Finally, paint in a few more "tree" symbols.

1 inch synthetic wash brush

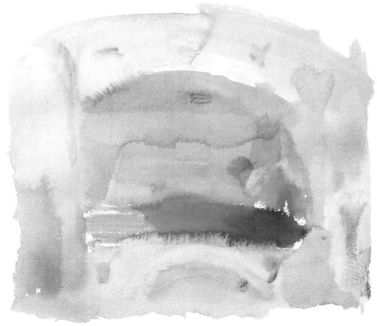

Colosseum, Rome
This picture is of the Colosseum and is based on a similar painting that was done from life. Though the composition seems very abstract, its starting point was the physical building in its famous Italian setting.

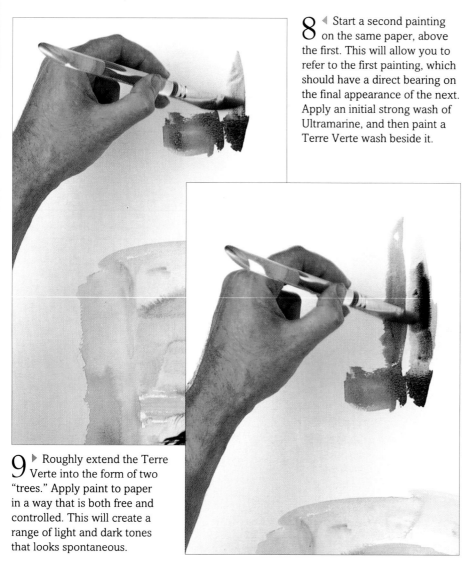

8 ◀ Start a second painting on the same paper, above the first. This will allow you to refer to the first painting, which should have a direct bearing on the final appearance of the next. Apply an initial strong wash of Ultramarine, and then paint a Terre Verte wash beside it.

9 ▶ Roughly extend the Terre Verte into the form of two "trees." Apply paint to paper in a way that is both free and controlled. This will create a range of light and dark tones that looks spontaneous.

10 ▲ Overlay Black on the trees, and then paint in some more trees, now with Terre Verte. Also apply more strokes of Black as a separate detail, and then apply a Turquoise wash along the bottom of the painting.

11 ▶ Apply the Turquoise to the left-and right-hand side of the composition. Again, the tonal difference in its application is dictated by the amount of paint that you have on the brush and the degree of dilution – the thicker the paint mix, the darker the color. Remember that colors become lighter as the paint dries, so allow for this in your mix.

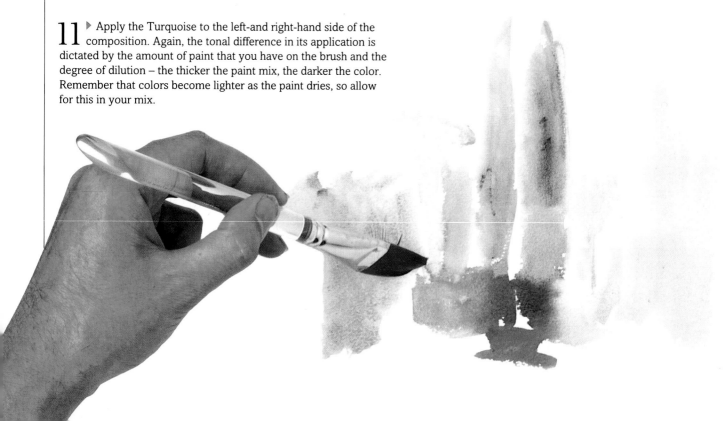

13 ▲ Apply Turquoise along the bottom edge of the painting, separating it in an area of white paper.

12 ▲ Paint an intense circle of Turquoise at the top left-hand side of the picture. If you take into account the rules that dictate the style and content of these paintings, you may be able to perceive a symbolic or representational meaning in an abstract mark like this. On the other hand, this stroke may have been included to create a point of focus or a visual balance, two crucial factors in any composition.

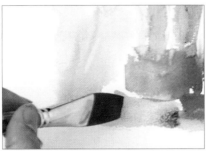

14 ▲ Overlay a wash of Rose Madder on the Turquoise wash running along the bottom edge of the painting. You should then work this up with a wet-in-wet technique, so that the colors blend together.

15 ▲ Apply more Turquoise along the right-hand edge of the picture. Paint it on loosely over an already dried wash of turquoise, but without working it up. Bring the second wash to a hard edge to create an abstract detail that represents a part of the landscape.

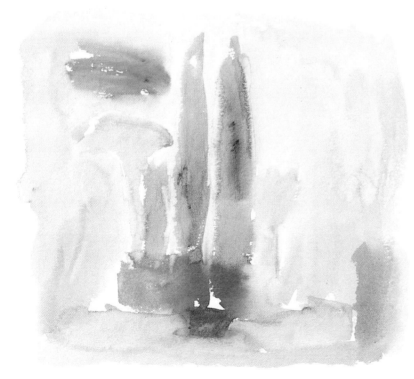

The Island of the Dead

In technique and color, these two paintings bear a strong resemblance to each other. The studies are the result of the artist's need to experiment on a range of different images using the same tonal qualities and colors. In doing this he explores the possibilities of expressing a variety of moods and scenes within the technical limitations he has set himself. He based his first study on a scene from nature and has succeeded in conveying a lost, misty landscape. The second is an imagined landscape and is entitled *The Island of the Dead*. The artist intended it as a metaphor for the perils that accompany artistic and human endeavor. Both works share a quality of loneliness.

ABSTRACT GALLERY

IN PARIS, JUST BEFORE the First World War, (1914-18) a group of painters made a radical departure from traditional painting. They introduced Cubism, an approach to pictorial art that disdained realism in favour of a more abstract reality. It was the start of a great movement that proclaimed that painting need "no longer be an image of something else but an object in itself." The selection here ranges from largely emotional paintings to abstract graphic designs.

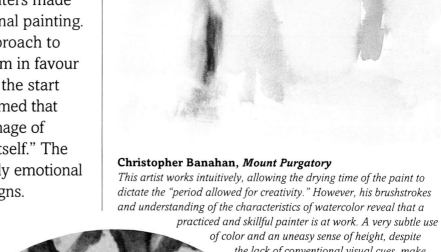

Christopher Banahan, *Mount Purgatory*
This artist works intuitively, allowing the drying time of the paint to dictate the "period allowed for creativity." However, his brushstrokes and understanding of the characteristics of watercolor reveal that a practiced and skillful painter is at work. A very subtle use of color and an uneasy sense of height, despite the lack of conventional visual cues, make a simple yet powerful, emotional impact on the viewer.

Rachel Moya Williams, *Stained Glass Design*
This watercolor was conceived as a design for a stained glass window. The outlines around the shapes and forms give definition to symbols of boulders, sunbeams and trees.

Concentrated pigment has been applied to the flat washes while they are still wet, and this has the effect of building up a variety of tones and hues.

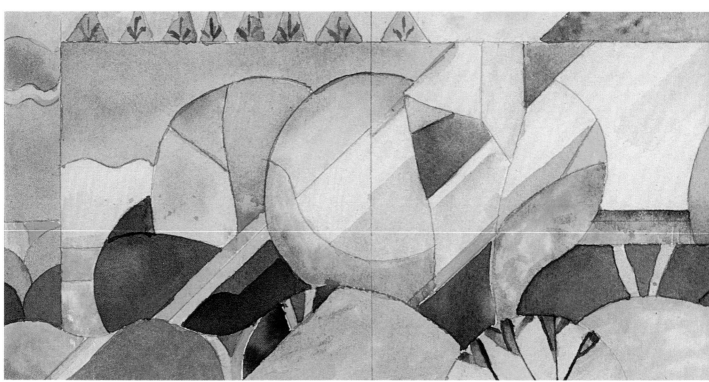

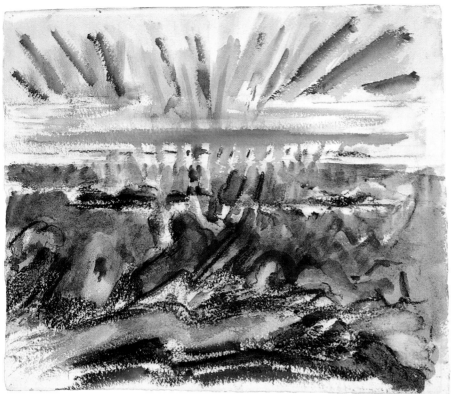

John Marin, *Sunset, Maine Coast,* 1919

John Marin was influenced by European art during time spent in Paris. On his return to the United States, he became influential in leading his fellow artists away from naturalistic representation toward an expressive semi-abstraction. His ideas are revealed in this watercolor. We recognize the sunset, but it is a thing of fiery emotion, set in a turbulent sea. Conventional depictions of atmosphere and light are abandoned and color is used to reveal the artist's subjective response to the scene.

Simple, broad bands of color have been arranged with a lyrical mastery. Very little mixed pigment has been applied and brushstrokes are bold.

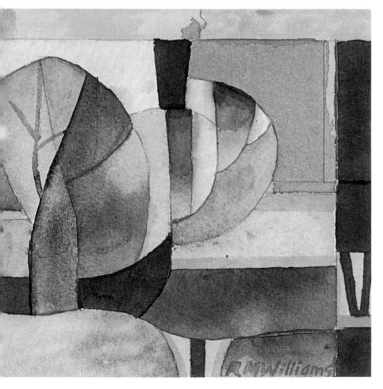

Gisela Van Oepen, *Untitled*

This painting is the final image in a series of studies of one mountain range. Van Oepen observes with intense concentration and prefers to go through a period of meditation before she starts to translate her subject into paint. During her work on this series, she looked for the essence of the mountains. This led her to discard and reject anything superfluous in her images. The logical conclusion to her search is this final study where land and light are reduced to pure line and color.

GLOSSARY

ABSTRACTION To reduce or synthesize the visual reality of the subject by depicting only one or some elements of it in a way that may or may not bear a resemblance to the subject.

ADJACENT COLOR Literally those colors that lie closest to each other on the color wheel; also used to describe colors that lie next to one another in a painting. Adjacent complementary colors appear brighter because each reinforces the the other.

ADJACENT WASH A wash that is applied directly next to another wash.

ADJACENT HARMONY A harmony made up of a series of adjacent colors, often relied upon to give a composition a subtle color unity.

ATMOSPHERE The atmosphere of a painting can be determined by a range of factors: the subject, the weather conditions, the effects of light falling on the landscape, the technique, and use of color.

BIAS A color, produced from two other colors will have a bias toward the color that has been used in the greater quantity, or the one with the greater tinting strength.

BLOCK IN Applying areas of color.

Blocking in

BODY COLOR *see* Gouache

BROKEN COLOR An effect created by dragging a brush over heavily textured paper so that the pigment sinks into the troughs and does not completely cover the raised tooth of the paper. A hair-dryer was applied over the original wash heightens the broken effect.

COLORED NEUTRAL A subtle color made by mixing a primary and secondary color in unequal amounts.

COLOR MIXING Combining two colors or more either in a palette or on the painting, to produce a third color. Different tinting strengths in colors make it very difficult to gauge the exact amounts of two colors needed to create a specific color. Simple trial and error is often the best means of creating the precise colors needed in a composition.

COLOR WHEEL A diagrammatic wheel, in which the colors red and violet at opposite ends of the spectrum are joined to form a full circle of color. Color wheels, or circles, take many forms, but at their simplest show the three primary colors and the three secondary colors arranged in such a way that each color's complementary is shown opposite it.

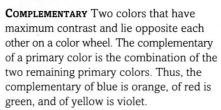

Color wheel

COMPLEMENTARY Two colors that have maximum contrast and lie opposite each other on a color wheel. The complementary of a primary color is the combination of the two remaining primary colors. Thus, the complementary of blue is orange, of red is green, and of yellow is violet.

COMPOSITION The arrangement of subjects on the paper. Ideally, these are placed in harmonious relationship with one another to create a strong sense of balance. In landscape painting perspective is a major part of composition.

COOL COLOR Generally a color such as blue is considered cool. Distant objects appear to be blue, so cool colors are said to recede. This effect is known as aerial perspective, which is an optical phenomenon that is caused by light waves traveling through water vapor and dust particles existing in the atmosphere.

EYE LEVEL Eye level can be determined by holding a pencil at arm's length in front of your eye and lining up your viewpoint and the pencil with a point in the landscape. This will indicate where your eye-level will be in a composition. (This eye-level is your horizon line on a landscape) The correct eye level is vital in order to create the right sense of perspective in a painting.

GOUACHE A type of watercolor paint that is opaque. This medium is also known as body color.

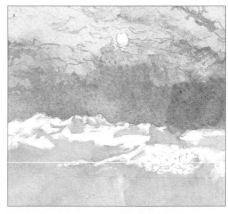

Applied gouache

GRADED WASH A wash that is applied to the paper by a process of gradually diluting or thickening the paint as the wash is applied, so that the tone in the wash runs smoothly from light to dark or dark to light. A sponge will give you more control over the paint.

HOT-PRESSED PAPER Paper that has a very smooth, untextured surface. HP

LANDSCAPE FORMAT A term used to describe a painting when the width of the composition is longer than the height.

LIFTING OUT The technique used to modify color and tone and to create highlights in a composition by removing paint from the paper using either a brush or a sponge. The paint can be removed from the paper when it is wet, or can be lifted out, when dry, with a wet brush, tissue, or sponge.

MASKING FLUID A rubber latex solution that is used to mask out, or reserve, certain areas from washes that will be laid over the rest of the composition. For instance, it may be used to keep clouds free of color. This technique can also be used to create a hard

 edge to a wash or to highlight specific areas. Masking fluid can be applied either to white paper or over a dry wash. It is available in white, or pale yellow to make it easily visible.

Applying masking fluid

MONOCHROME In painting, a study using one color in a variety of tones.

NEGATIVE SHAPES The shape of an object created without directly painting the object itself, so that the colors surrounding the space actually become the outline of the negative shape.

NOT PAPER A paper with a fine grain or semi-rough surface; it is also referred to as CP or Cold-Pressed paper.

OVERLAID WASH A wash that is applied directly over another that has already dried. This is the method used in watercolor to darken the tone. The translucent colors show through each layer and thus the hue is deepened.

Three colours overlaid

PERSPECTIVE The method of representing a three-dimensional object on a flat surface. Linear perspective makes distant objects appear smaller. Aerial perspective creates a sense of depth by using cooler, paler colors in the distance and warmer, brighter colors in the foreground.

PIGMENT Any material used as a coloring agent. Watercolor is combined with a water-soluble medium. This is then diluted so that the pigment can be applied to paper.

POOL Intense color that may accumulate on the brush at the end of a wide brushstroke. Usually unwanted.

PORTRAIT FORMAT A term used to describe a painting when the height of the composition is longer than its width.

RECESSION The optical illusion of aerial perspective is that distance recedes into pale hues. This tonal recession is revealed through the use of color tones.

REFLECTION In water, the color of the reflection is affected by the water's clarity.

ROUGH PAPER Heavily textured paper.

SATURATION The degree of intensity of a color. Colors can be saturated, i.e., vivid and intense of hue, or unsaturated, i.e., dull tending toward gray.

SCRATCHING OUT *see* S'graffito.

SCUMBLING Opaque paint dragged over another layer of paint so that the first layer shows through in patches. In watercolor this is often done with coarse hair brushes, which are slow to absorb moisture.

SECONDARY COLOR Green, orange, and violet, the colors arrived at by mixing two primaries and that lie between them on the color wheel.

S'GRAFFITO Removing paint by using a scalpel or any other device, such as the end of a brush, so that the color beneath, or the white paper, is revealed. This technique can be used to create subtle highlights, such as light reflecting off the surface of the sea.

SPECTRUM Light passed through a prism will divide into the colors that are shown on a color wheel. This color spectrum is the basis of all color theory. However, it is based on human observation, and current research suggests that light contains many more colors than can be detected by the human eye.

SPONGING OUT The technique of soaking up paint with a brush, sponge, or paper towel so that areas of pigment are lightened or removed from the paper. Can be used to rectify mistakes or to create effects.

STRETCHING PAPER Watercolor paper is stretched to prevent it from buckling when paint is applied. The paper is dampened, attached to a board with gum tape, and allowed to dry.

TERTIARY COLOR Colors that contain all three primaries. The result of mixing a primary with its adjacent secondary color.

TINTED PAPER Paper with a slight color. Oatmeal, pale blue, or gray are popular for watercolor.

TONE The degree of lightness or darkness in an object due to the effect of light.

VIEWFINDER A cardboard rectangle held to the eye to isolate and frame sections of the scene in front of you.

Card viewer

WARM COLOR Generally a color like orange-red is considered warm. In accordance with atmospheric or aerial perspective, warm colors appear to advance toward the viewer whereas cool colors appear to recede.

WAX RESIST Using wax to make patterns and shapes on the surface of the paper. Use a wax candle, and apply thickly to those parts of the paper that are to be protected from paint. It can be used to bring texture to the grain of the paper, or applied to bring texture to a color wash that has dried thoroughly.

Wax resist used for an image of grass

WET-IN-WET A process of adding on paint to a wet layer of paint already applied to the surface of the paper. Merging washes in this way is an effective way of mixing colors.

A NOTE ON COLORS, PIGMENTS AND TOXICITY

In recommending certain colors, we have, in some cases, used trade names of paints manufactured by Winsor and Newton Ltd. Other manufacturers have their own trade names. The particular pigments that we have recommended are as follows: Winsor Green: Phthalocyanine, Winsor Yellow: Arylamaide, Winsor Violet: Dioxazine and quinacridone, and Permanent Rose: quinacridone. If you have any doubts about the pigment you are buying, you should refer to the manufacturer's literature.

We have tried to avoid recommending pigments, such as the Chrome colors, which carry a significant health risk. In the case of colors such as the Cadmiums, however, there is nothing commercially available that matches them for color and permanence. There is no danger in their use nor in that of other pigments provided artists take sensible precautions and do not lick brushes with paint on them.

A NOTE ON BRUSHES

The brush sizes given here refer to Winsor & Newton brushes. They may vary slightly from those of other manufacturers. In the step-by-step pages, the terms small, medium, and large are used to denote a range of brushes that may be used.

A NOTE ON PAPERS

The surfaces of papers – Rough, Hot-Pressed, and NOT (semi-rough), vary noticeably from one manufacturer to another so it is worth looking at several before deciding which to buy.

INDEX

ACKNOWLEDGMENTS

Dorling Kindersley would like to thank:

Artworks

Christopher Banahan: pp.64-67 Sharon Finmark: pp.18-19, pp.22-27, pp.30-33 Julian Gregg: pp.50-55, pp.58-63 Noel McCready: endpapers p.4 Julie Parkinson: endpapers p.2 Tim Pond: pp.10-15, pp.36-39, pp.42-47.

Picture credits

Key: t=top, b=bottom, l=left, r=right

p.5,6&7 Pigments and Art Materials by kind permission of The Winsor and Newton Museum, Harrow p.6 tl: Dürer, House on an Island in a Pond, By Courtesy of the Board of Trustees of the V&A/Bridgeman Art Library, London p.7 tl: Turner, On the Rhine, By Courtesy of Trustees of the V&A/Bridgeman Art Library, London p.7 br: McBey, Philadelphia 1939, The Fine Art Society, London/Bridgeman Art Library, London p.16 l: Constable, Bridge with Trees and Buildings at Haddon, By Courtesy of

the Board of Trustees of the V&A/Bridgeman Art Library, London p16-17 b: Lorrain, View of the Tiber From Monte Mario, British Museum pp.28-29 b: Sandby, Landscape Study, By Courtesy of the Board of Trustees of the V&A/Bridgeman Art Library, London p.29 tr: Varley, Landscape 1840, By Courtesy of the Board of Trustees of the V&A/Bridgeman Art Library, London p.34 b: Fielding, A Mooorland, Oldham Gallery, Lancs p.35 b: Cézanne, Monte Saint Victoire, Tate Gallery, London/Bridgeman Art Library, London p.36 b: Wyeth, Morning Lobsterman, Visual Art Library, London p.37 t: Homer, Rowing Home, Private Collection/Bridgeman Art Library, London p.40 b: Constable, Old Sarum, By Courtesy of the Board of Trustees of the V&A/Bridgeman Art Library, London p.41 r: Turner, Bellinzona, Oldham Art Gallery, Lancs pp.48-49 b: Holman Hunt, The Holy City, Oldham Art Gallery, Lancs p.49 tl: Macke, A Glance Down an Alleyway, Stadt Museum, Mulheim/Bridgeman Art Library, London p.69 t: Marin, Sunset Off the Maine Coast, Gift of Ferdinand Howald/Columbus Museum of Art, Ohio.

Thanks also to Alun Foster and Emma Pearce at Winsor and Newton Ltd for helping with queries, to Tessa Paul and Michael Wright for their extensive work on the text, to Margaret Chang for further editorial assistance and to Maria D'Orsi for design assistance.